IMAGES

of Modern America

THE WILD GARDENS
OF ACADIA

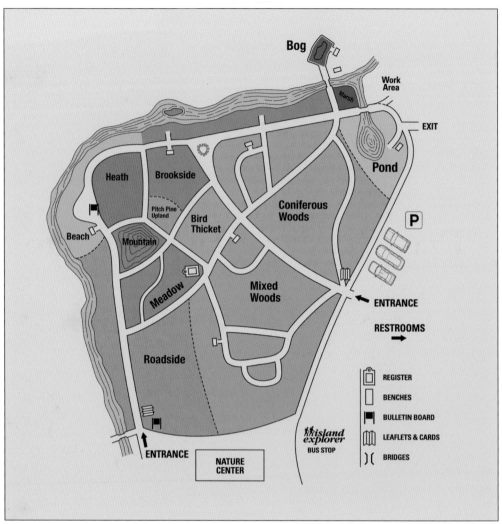

This is the current map of the Wild Gardens of Acadia. (Courtesy of the Wild Gardens of Acadia [WGA] and Leelah Holmes.)

ON THE FRONT COVER: Clockwise from top left: Entering the gardens (courtesy of Josh Winer), art in the gardens (courtesy of Phyllis Mobraaten), cleaning the brook (courtesy of WGA), building a habitat (courtesy of WGA; see page 60), yellow lady's slippers (courtesy of Josh Winer; see page 36)

ON THE BACK COVER: From left to right: Trailing arbutus (courtesy of Josh Winer; see page 33), marsh marigold (courtesy of Josh Winer), rose pogonia (courtesy of WGA; see page 77)

IMAGES
of Modern America

THE WILD GARDENS
OF ACADIA

Anne M. Kozak and Susan S. Leiter

ARCADIA
PUBLISHING

Published by Arcadia Publishing
Charleston, South Carolina

Printed in the United States of America

Library of Congress Control Number: 2015947012

For all general information, please contact Arcadia Publishing:
Telephone 843-853-2070
Fax 843-853-0044
E-mail sales@arcadiapublishing.com
For customer service and orders:
Toll-Free 1-888-313-2665

Visit us on the Internet at www.arcadiapublishing.com

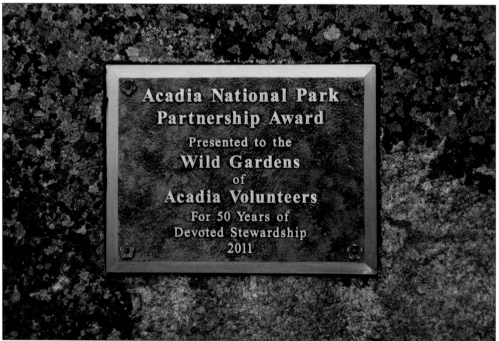

As part of the celebration of the Wild Gardens' 50th anniversary in 2011, Acadia National Park presented the Wild Gardens of Acadia volunteers with a partnership award in recognition of the group's work not only in developing and maintaining the gardens but also for its stewardship. Former Acadia National Park deputy superintendent Len Bobinchock chose the stone and the site for the plaque. *The Wild Gardens of Acadia* is dedicated to all who have stewarded the Wild Gardens. (Courtesy of Josh Winer.)

CONTENTS

ACKNOWLEDGMENTS

Special thanks go to Josh Winer and Genie Thorndike. Josh not only took many of the images in this book but also scanned and uploaded them; his help in choosing images was invaluable. In addition to being a sounding board for ideas and ways to proceed, Genie copyedited multiple revisions. We also thank our editor, Caitrin Cunningham, and Arcadia Publishing's production team for their support, encouragement, and professionalism.

A special thanks goes to College of the Atlantic (COA) for its ongoing support and for granting Anne M. Kozak a sabbatical in the spring of 2015 to work on the book. Barbara Carter, administrative assistant to the faculty, helped in converting texts to various formats. A special thanks also goes to COA's writing tutors who printed, copied, and researched material and documents.

Acadia National Park superintendent Sheridan Steele and Friends of Acadia president David MacDonald offered support not only during the concept stage but also as the book progressed. We are indebted to them. Wild Gardens of Acadia head gardener Geneva Langley, COA botanist Nishanta Rajakaruna, and Acadia National Park's Rebecca Cole-Will and Lynne Dominy all reviewed the book for content and provided us with useful comments.

While Josh Winer and the unidentified photographers of slides in the Wild Gardens' archives contributed images, others also made their images available to us. Our thanks go to Devin Altabelto, Aimee Beal Church, Kristina Beal, Stephanie Clement, Floy Ervin, Mel Hodder, Leelah Holmes, Lisa Horsch Clark, Helen Koch, Tom Lawrence, Phyllis Mobraaten, Carole Plenty, Ella Samuel, Charlotte Stetson, and Julia Thomas.

We also extend our thanks to our families and friends for their support and patience and to those, predominantly women, who developed the gardens and passed on to us and other committee members their deep-rooted commitment to making the Wild Gardens of Acadia one of Acadia's top attractions. We can't thank them enough.

INTRODUCTION

While the images and captions that follow depict how the Wild Gardens of Acadia (WGA) developed and grew over the years and the many people who played pivotal roles in ensuring that growth, the actual beginning of the gardens was inauspicious and serendipitous. Janet TenBroeck, conservation chair of the Bar Harbor Garden Club (BHGC), became interested in native wildflowers when she saw lists of flowers "not to be picked," and she sought to "discover reasons for their scarcity and perhaps to overcome it." In 1960, she held a competition and offered a prize to the person cultivating the greatest number of native plants. The 1961 prize went to the person who grew the most plants from the "restricted" list. In a handwritten piece, "As I see it," TenBroeck wrote: "Sally Hubler was active with me on this project, and one afternoon in the presence of our husbands, I revealed that we and the local community knew so little about the native plants that it would be good if they could be planted and named in a public place. To my surprise Hal [Harold Hubler, then superintendent of Acadia National Park] said, 'You could have a place in the park to do it.' "

TenBroeck and Dorcas Crary, who had extensive knowledge of native plants, met with the park's landscape architect, Elijah Whitaker, and park naturalist, Paul Favour, to find a suitable site. Although they initially preferred a location farther west, the park chose Sieur de Monts Spring because of its accessibility to parking and its location—this area was the original hub of Acadia National Park. The Sieur de Monts area—as well as 17,128 acres on the east side of the island, including 8,750 acres in Acadia—had burned in the 1947 wildfire. While the park had rebuilt the nearby Nature Center and other buildings at Sieur de Monts Spring, in 1961, the adjacent three-quarter-acre site that was to become the Wild Gardens of Acadia consisted of a mass of tangled blackberries and scarred red maples, but fortuitously it had a brook and along the brook a stand of royal ferns.

Although some believe that the park asked the BHGC to establish a wildflower garden, the archival evidence does not support that view. In addition to TenBroeck's reminiscence, there are also the remarks of Elizabeth Thorndike at the 25th anniversary of the gardens: "His [Hubler's] impromptu offer of a three-quarter–acre site in the park for our garden came like a burst of fireworks exploding with undreamed-of possibilities. It might be called serendipity!"

Early archival notes indicate that the Wild Gardens committee was only loosely formed from 1961 to 1964 and became more formalized in 1965 with Thorndike as chair, Crary as vice-chair, and TenBroeck as treasurer. The original committee also included Elizabeth Owens of the Garden Club of Mount Desert, Eunice Fahey of the Bass Harbor Garden Club, and nonclub members Amy Garland and Marion Burns. Other members were Mary Hodgkins, Sally Fox, Amy Biggs, Clara and Esther West, and Sally Hubler.

Although initially developing the Wild Gardens was nominally a project of the BHGC, the Wild Gardens committee operated as an independent group responsible for developing and maintaining the gardens, recruiting new members, electing officers, and raising its own funds. Throughout the gardens' history, the committee included both BHGC members and nonclub members. As the archives indicate, this independent status and determining who could be on the committee were recurring topics through the mid-1980s. Despite those regular discussions, TenBroeck, in recruiting new members, only specified that they must work in the gardens or contribute funds and/or materials.

In October 1964, Janet TenBroeck and Elizabeth and Amory Thorndike met with Hubler to discuss whether "it would be suitable for us to organize the Wild Gardens of Acadia as a separate organization, outside the Bar Harbor Garden Club, for reason of enlisting a more broadly representative group geographically, and with both men and women members," wrote Elizabeth Thorndike in an October 24 letter recounting the details of the meeting. In this letter, Thorndike also notes that before approaching Hubler, they had discussed the subject with BHGC's executive committee, and the committee encouraged their exploring the possibility. Hubler advised them that should the Wild Gardens become independent of an entity such as the BHGC or the Bar Harbor Village Improvement Association (VIA), the committee would have to submit a proposal to Washington, and its activities would be beyond his scope.

The October 24 letter also notes that Hubler gave them a written statement about the purpose of the gardens—to display, preserve, and propagate Acadia's native plants in habitats simulating their natural plant communities. Hubler complimented the committee for its work thus far and urged it not to make the gardens an arboretum with Latin and common names. Despite his latter point, the committee did and still does use both Latin and common names—to the benefit of botanists and many non–English speaking visitors.

As Elizabeth Thorndike noted in her 25th-anniversary speech, from the initial efforts of the committee, the Garden Club of Mount Desert, a summer club, "realized we were in for a long pull, and cheered us on with a grant of $150 a year for three years. This club's subsequent generosity and that of many other kind friends have been a constant source of encouragement."

Over the years, the gardens have been maintained not only by such gifts and gifts from committee members but also by revenue from plant sales, postcards, and the garden brochure depicted on page 94. As the archival notes and Thorndike's diaries show, WGA committee members regularly purchased materials or paid interns who worked in the spring or fall as well as Ted Mitchell who worked each week in the gardens from the beginning. These notes also refer to the names of Owens's and Thorndike's gardeners who regularly worked as needed.

The gardens also received help from the park. Until 2014, the park paid the salary of at least one intern each summer, and in the early years, the park employed two. In addition to this help, the park surveyed and cleared the land in 1961 and continues to provide and maintain the gardens' infrastructure. "Throughout these 25 years, the long-suffering park has supported us in countless ways and we are proud to be playing a part in its contribution to the education and pleasure of its visitors," said Elizabeth Thorndike in 1986—an observation that is still true today.

But as the core members of the Wild Gardens committee learned in the late 1990s, they had neither the physical nor financial means to maintain the gardens and oversee their daily operations. Not only had the gardens evolved into a garden of complex plant communities, but park visitation had increased considerably, and that increase directly impacted the gardens. To ensure the gardens' long-term viability, the committee needed more committed volunteers and a mechanism that would ensure regular funding for garden operations. While the committee raised some funds to hire an additional intern, there were still staffing issues—issues that will likely continue as park visitation and interest in gardening with native plants increase.

In 2004, Anne Kozak, Don Smith, WGA cochairs Susan Leiter and Barbara Cole, and WGA volunteer and member of the BHGC Raymond Rappaport met with park management staff and Ken Olson, then president of Friends of Acadia (FOA). They presented three options: the park could assume full responsibility for the gardens; the gardens could simply be let go; or the committee, FOA, and the park could work jointly to find a sustained funding source. Fortunately for the WGA committee and the park's many visitors, the management team, FOA, and the committee agreed to work toward finding long-term, sustained funding to support the gardens' operations. The committee was particularly encouraged that the park and FOA wanted the gardens to continue and agreed to work with the committee on developing a long-term management plan.

While the WGA executive committee explored options with the Mount Desert Land and Garden Preserve, Maine Community Foundation, and Friends of Acadia, FOA continued to make

a substantial annual gift to support a summer employee. Although it took six years and the support of Olson, FOA board chair Lili Pew, subsequent FOA president Marla O'Byrne, FOA staff, the park's management team, and superintendent Sheridan Steele, in 2010, the park and FOA signed a memorandum of understanding making the Wild Gardens committee a subcommittee of Friends of Acadia—an agreement that ensures the long-term oversight and viability of the gardens.

In developing the gardens and taking on the name Wild Gardens of Acadia in 1961, the committee, although initially unwittingly, was fulfilling a dream of George B. Dorr, founder and first superintendent of Acadia National Park. In 1908, Dorr purchased a tract of land at Sieur de Monts Spring, and in 1916, when Dorr formed the corporation Wild Gardens of Acadia, he wrote: "The purpose of the Wild Garden Corporation is to provide sanctuaries for the plant and animal life—the flora and fauna of the Acadia region—and to make these sanctuaries useful not only in conservation but as an opportunity for study, a source of pleasure and information."

Over much of the gardens' history, the members did not appear to know the extent of Dorr's interest in displaying wild plants along garden paths leading from the village of Bar Harbor to Sieur de Monts Spring. Beginning in the late 1800s, to protect the land and to ensure public access, Dorr purchased numerous tracts of land around Champlain Mountain and Beaver Dam Pool and along Schooner Head Road, Cromwell Brook, and the Great Meadow—all areas near or leading to Sieur de Monts Spring. In addition to Dorr's purchasing land, other land was purchased or donated by wealthy summer residents. These lands were turned over to the Hancock County Trustees of Public Reservations, a land trust established in 1901. Most of these lands were donated to the federal government in 1916, when the Lafayette National Monument was established by Pres. Woodrow Wilson (monuments can be established without Congressional approval). In 1919, Congress designated the area as Lafayette National Park, and in 1929, its name was changed to Acadia National Park.

Along with Bar Harbor VIA members, Dorr built or oversaw construction of a number of bicycle and walking paths over the course of about 30 years. Prior to 1913, Dorr also developed the Wild Gardens Path. According to *Pathmakers* (2006), this path had many iterations. One description of the path shows the path extending from the glade by the spring at Sieur de Monts to the north end of the Tarn and included the Delano Wild Gardens, a garden funded by Annie Delano Hirch, a maternal aunt of Pres. Franklin D. Roosevelt. In 1990, the park reopened this path, a path, like many others, that had not been maintained. Yet another iteration of the Wild Gardens Path describes the trail as crossing the Great Meadow, which is just to the north of the current Wild Gardens. A 1914 map shows Dorr's plan for developing a series of gardens—wild heath and bird gardens as well as maple and beech woods. Historically, it is unclear to what extent Dorr developed this concept, but aerial photographs from the 1940s and 1950s show that some of these garden spaces in the Great Meadow were built although not in the marked locations.

"Only gradually did we realize that we were entering the dream of George B. Dorr who so loved this very site that he called it 'Wild Gardens of Acadia.' It was part of a grandiose plan to reserve large tracts of land throughout the state of Maine for educational and research purposes," said Elizabeth Thorndike in 1986.

On a Sunday morning in late September 2015, a group of botany students and two professors from Bates College in Lewiston, Maine, visited the gardens to learn more about native plants and to compare the plants here with those, like rattlesnake plantain, that they had found near Bates. These students were not an exception but rather the norm. Since the gardens' inception, students of all ages—from pre-kindergarten to college—regularly visit; for College of the Atlantic students taking courses such as "Trees and Shrubs of Mount Desert Island," the gardens are a unique resource.

In a 2012 article in the *Friends of Acadia Journal*, Acadia seasonal ranger David Donovan referred to the gardens as a "unique and wild teacher." Donovan and his wife have visited numerous national parks, "but nowhere did we find a perfect, quiet place to learn the names of the plants that call these national parks home."

It is not an accident that the Wild Gardens so uniquely complement not only Dorr's vision to "provide sanctuaries" for plants and to educate visitors about Acadia's native flora but also the vision of the founders of the Wild Gardens. Over the years, committee members have strived to display, propagate, preserve, and label native plants in communities simulating those found in the park. In their care of the gardens, committee members also foster stewardship—ensuring that the gardens continue to be preserved through volunteers and private philanthropy.

In her remarks at the 50th anniversary of the gardens in 2011, Anne Kozak said that "while a number of people were active in establishing the gardens, some—particularly Betty Thorndike, Janet TenBroeck, Betty Owens, Ruth Goldthwait, Katrina Hummel, Dorcas Crary, and Ruth Soper—turned out not only to be long-term volunteers but extraordinary mentors for me, Sue Leiter, Bobbie Cole, and countless others. From them, committee members learned more than just how to cultivate and maintain plants native to Mount Desert Island, they also learned how to work collaboratively, how to ensure the long-term viability of the gardens as a source of inspiration to residents and visitors, how to lobby for the best interest of the gardens."

All author royalties from the sale of this book will benefit the Wild Gardens' endowment at Friends of Acadia.

One

GETTING STARTED

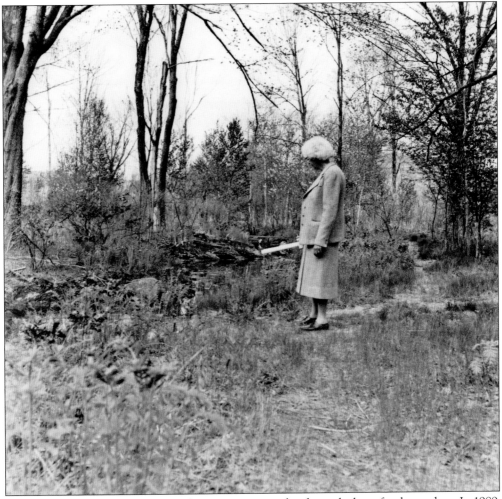

Janet TenBroeck contemplates the three-quarter-acre plot the park chose for the gardens. In 1989, the Massachusetts Horticultural Society awarded TenBroeck and Elizabeth Thorndike silver medals for their efforts in establishing the gardens. "We took an undifferentiated piece of land," said TenBroeck, "and made it seem as if the deciduous and coniferous woods, meadow, bog, and pond were always there. It's been a slow process, but it's coming." (Courtesy of WGA.)

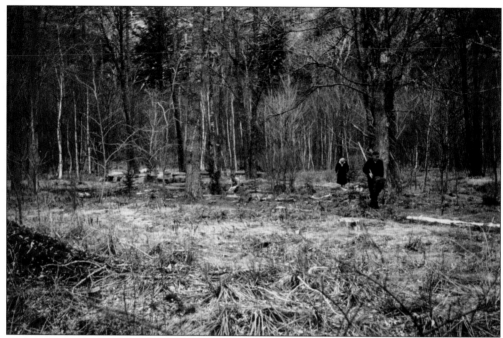

Although the three-quarter-acre plot was covered with blackberry bushes and mature red maples scarred by the 1947 wildfire, its assets included a wealth of large ferns and a winding brook fed by Sieur de Monts Spring. In 1961, with the help of park crews who cut trees and cleared brush, Wild Gardens committee members began to lay out paths and divided the gardens into areas simulating the natural plant communities of Acadia National Park—communities that varied in shade and soil composition and included mountains, bogs, marshes, meadows, beaches, and deciduous and coniferous woods. (Both, courtesy of WGA.)

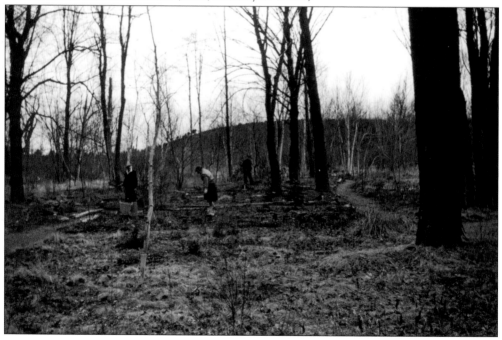

The above photograph, taken in 1962, is labeled "central area before clearing." While no specific area of the gardens is labeled "central," this appears to be close to what are now the Mixed Woods habitat and the gardens' fern collection. The below photograph, taken in 1963, is labeled "central area early plantings" and shows the progress made in just one year; that progress was underscored by members of the New York Horticultural Society (pictured) who visited the gardens, praised the committee for its efforts, and offered encouragement. (Both, courtesy of WGA.)

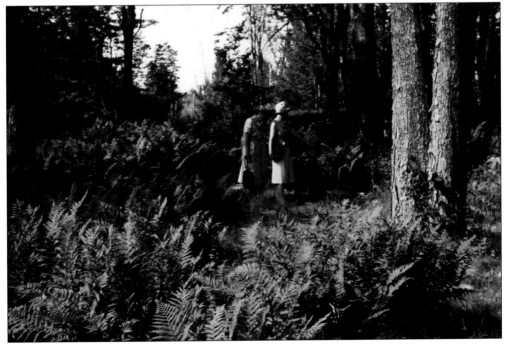

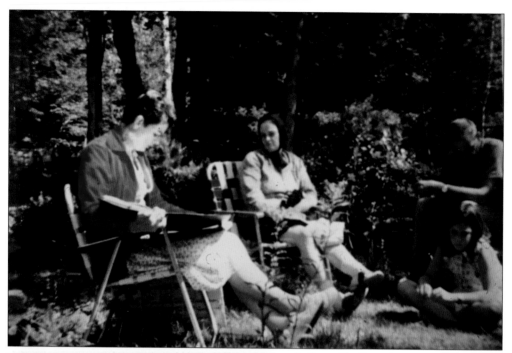

As Janet TenBroeck repeatedly stated, Dorcas Crary (at far left in the above photograph) was the only true botanist among committee members. In addition to playing an important role in laying out the framework and guiding principles for the gardens, Crary regularly gave horticultural talks on topics ranging from ferns to orchids. Elizabeth Thorndike's diary entry for June 4, 1966, notes that park superintendent Tom Hyde and his wife, Norma, attended Crary's talk on orchids. (Courtesy of WGA.)

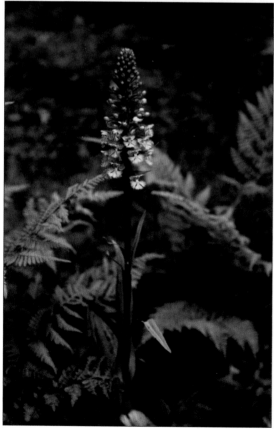

"During that first summer as we hacked away at blackberries and 'aliens'—nonnative plants like guilder rose, lilac, and ninebark—Dorcas Crary performed a symbolic act which raised our sights, our hopes, and our emotions. She rescued a fine clump of the somewhat rare purple-fringed orchid (*Habenaria fimbriata*) [now called *Platanthera grandiflora*] from the path of a road crew's bulldozer," wrote Janet TenBroeck. (Courtesy of WGA.)

The park stipulated that the gardens could display only native plants and that plants could not be collected in the park. In determining which plants were indigenous, the committee used E.T. Wherry's *The Wild Flowers of Mount Desert Island, Maine* (1928). Volunteers rescued plants from construction sites, propagated plants from seed, and with permission of landowners collected throughout Hancock and Washington Counties. In the image at the right, before going out on a collecting trip, Elizabeth Owens (foreground) and Janet TenBroeck conferred with Dr. A.E. Brower, state entomologist and naturalist. Brower shared his knowledge of native plants and encouraged members to join Maine's Josselyn Botanical Society. Below, on another collecting trip, committee members loaded plants into TenBroeck's car. (Both, courtesy of WGA.)

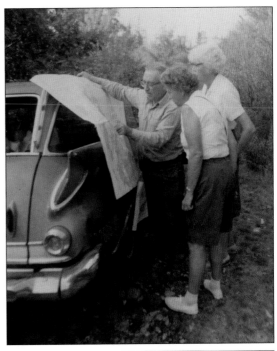

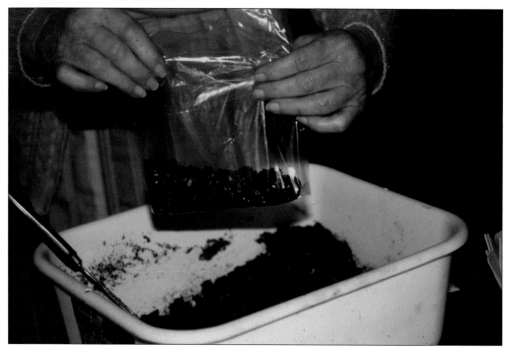

One way of propagating plants difficult to find in the wild is to collect seeds and overwinter them in the refrigerator. Thanks to the efforts of Patricia Scull, the gardens displayed plants like seaside bluebells (*Mertensia maritima*), a plant that as a result of glacial action is at the southern limit of its range. In addition to propagating *Mertensia*, Scull each fall collected seed from two irises—Arctic blue flag (*Iris hookeri*) that is at the southern limit of its range and blue flag iris (*Iris versicolor*), a plant at the northern limit of its range. Scull dried seeds, overwintered them in her refrigerator, and then potted them up to germinate. (Both, courtesy of WGA.)

Beginning in 1963, Mary Hodgkins annually brought a flat of cardinal flower (*Lobelia cardinalis*) to the gardens. Although cardinal flower bloomed abundantly in Hodgkins's garden, it seldom survived a winter in the Wild Gardens. Carl Linnaeus named the genus *Lobelia* for Matthais de Lobel (1538–1616), a French botanist and physician. (Courtesy of WGA.)

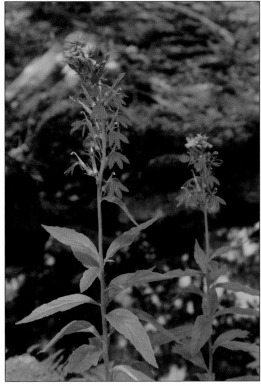

According to Elizabeth Thorndike's 1972 garden diary, the cardinal flower pictured here was in full bloom when a fifth-generation descendent of Matthais de Lobel visited the gardens. (Courtesy of Josh Winer.)

Janet and Carl TenBroeck discuss the gardens with Supt. Harold Hubler (center) at the original park headquarters on Main Street in Bar Harbor. Hubler cautioned the committee not to think of the gardens as an arboretum where specimens are minutely classified. Rather he advocated using only common names, for botanical names could "frighten many and may discourage their learning." Janet TenBroeck later wrote: "Happily we disregarded this advice to the benefit of visitors unfamiliar with our local common names and the many students and botanists who visit the Gardens." (Courtesy of WGA.)

Bunchberry (*Cornus canadensis*) is a common spring flower whose clusters of white flowers give way to red berries. Botanists recently reclassified bunchberry and now call it *Chamaepericlymenum canadense*. (Courtesy of WGA.)

According to archival notes, once the committee decided to be more botanically correct and to make names of plants more accessible to non-English speaking visitors, it began looking for labels. In 1965, Arthur Stover, a local sign painter, suggested using strips of heavy plastic attached to wooden stakes. Stover cut the plastic, and Julia Knickerbocker hand lettered the slips with common and Latin names. Carl TenBroeck cut redwood stakes of varying lengths and attached the slips with screws and epoxy. In 1967, the park purchased metal standards and embossed slips. The above photograph of the Beach displays the different types of standards used in the early days of the gardens. The first stainless steel standards (pictured below) were introduced in 1978. (Above, courtesy of WGA; below, courtesy of Josh Winer.)

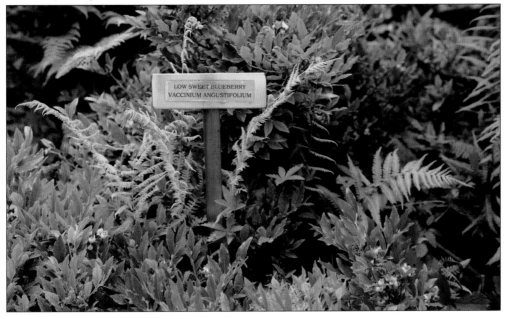

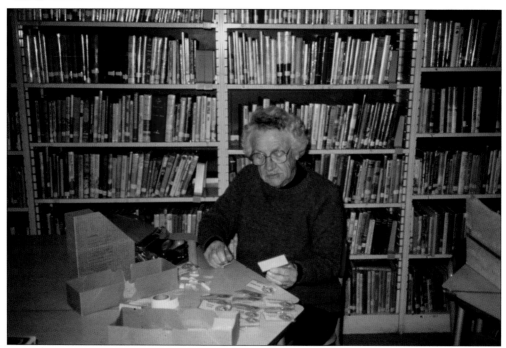

After retiring from The Jackson Laboratory in Bar Harbor, Katrina Hummel (pictured above) brought her meticulous observation and record-keeping skills to the gardens. She not only made name tags—a laborious process involving cutting and laminating, then gluing a pin onto the back—but took over record keeping. As shown below, each record included botanical and family names, description, flowering times, and how and when each plant was procured. (Above, courtesy of WGA; below, courtesy of Josh Winer.)

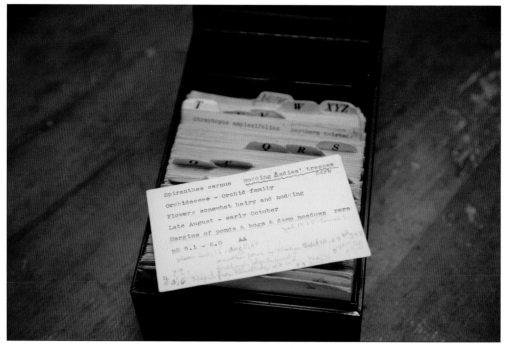

Although committee members were experienced gardeners, they possessed limited knowledge about growing native plants. In addition to using E.T. Wherry's book, *The Wild Flowers of Mount Desert Island, Maine*, they consulted Rand and Redfield's 1894 survey of Mount Desert Island's plants and the few native plant publications available in 1961. Committee members sought advice from experts at the University of Maine, Maine Entomological Society, Josselyn Botanical Society, New York Horticultural Society, and the Garden in the Woods. These resources remain valuable and are still regularly consulted. Here, Ella Samuel, a 2015 intern from College of the Atlantic, is in the shed at the gardens checking out information in Wherry's book. (Courtesy of Josh Winer.)

Dr. Edgar T. Wherry (1885–1982) first visited the Wild Gardens in September 1965 on his 80th birthday, but his connection to the native plants of Mount Desert Island began earlier. On several occasions, at the request of George B. Dorr, founder and first superintendent of Acadia National Park, Wherry visited the island to study the influence of soil on the cultivation and distribution of native plants. In 1925, the Garden Club of Mount Desert invited Wherry to lecture on preserving native plants, and in 1927, Wherry asked the club to publish his book, *Wild Flowers of Mount Desert Island, Maine*. (Above, courtesy of WGA; below, courtesy of Josh Winer.)

WILD FLOWERS

of

Mount Desert Island, Maine

By

EDGAR T. WHERRY
Bureau of Chemistry and Soils,
U. S. Department of Agriculture
President, Washington, D. C., Chapter,
Wild Flower Preservation Society

PLATE 1. Mount Desert Island's finest color effect: The Great Meadow in early June when Rhodora is in bloom, as seen from Dry Mountain (Flying Standards).

Two

MOUNTAIN AND
PITCH PINE UPLAND

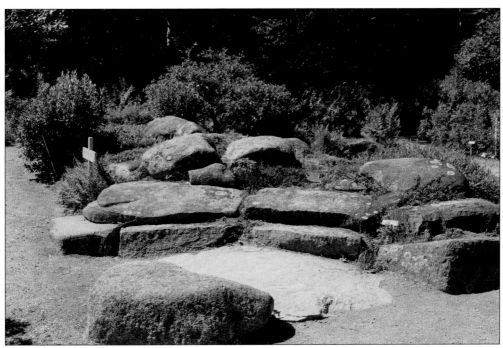

Since the original plot given to the committee was flat and undifferentiated, the Mountain habitat had to be constructed to depict the barren mountaintops found throughout Acadia. Boulders were moved in and arranged while appropriate plants were located and collected outside the park. (Courtesy of WGA.)

Although the Mountain habitat was designated in 1962, it was a "dream until the next year when Acadia's superintendent Harold Hubler designed and erected a handsome construction of great stones which became affectionately known as Mt. Hubler, or Hal's Hill," according to archival notes. (Courtesy of WGA.)

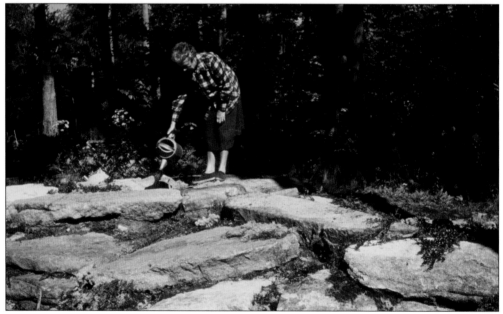

By the spring of 1963, the native columbine (*Aquilegia canadensis*) that Elizabeth Thorndike grew from seed was ready to be planted on the Mountain, a habitat displaying plants that grow naturally at higher elevations. To ensure its survival, Thorndike regularly watered it, setting an example of stewardship for future volunteers. (Courtesy of WGA.)

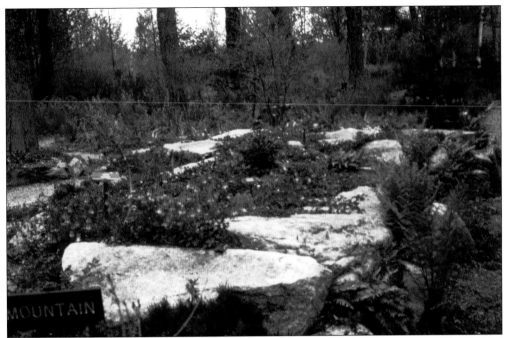

At one time, wild columbine had flourished on Mount Desert Island, but by 1962–1963, it had become less abundant. The committee hoped that once columbine was established in the gardens, divided plants could be sold at the annual plant sale. (Courtesy of WGA.)

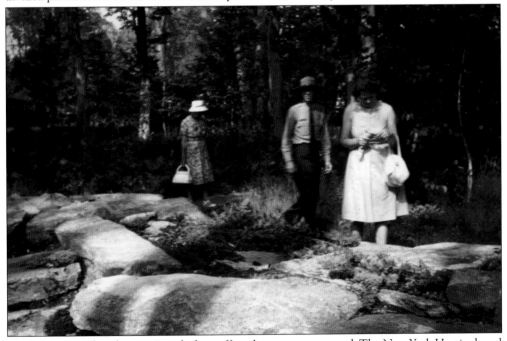

According to archival notes, "word of our efforts began to get around. The New York Horticultural Society promised to visit us the next year [1963] and did so with words of encouragement." This picture shows New York Horticultural Society members viewing the Mountain habitat. (Courtesy of WGA.)

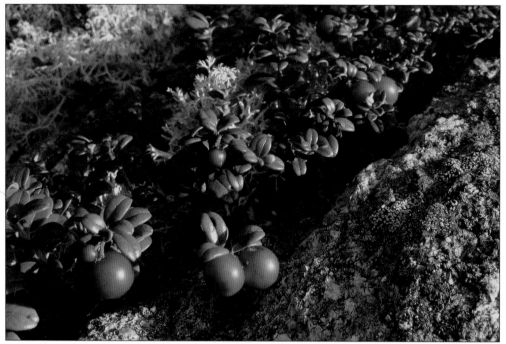

Mountain cranberry (*Vaccinium vitis-idaea*) is one of three cranberries native to Acadia National Park. While this cranberry is edible, its red berry is juicy but very small. In Scandinavia, this is known as lingonberry and is used extensively as a food source. (Courtesy of Tom Lawrence.)

While mountain cranberry is found in colder, more alpine areas, bear oak (*Quercus ilicifolia*)—sometimes called scrub oak—is at the northern limit of its range and is found on Acadia Mountain in the park. (Courtesy of Josh Winer.)

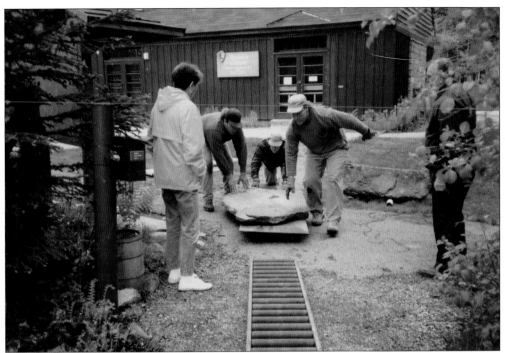

Because of the effects of wind, snow, rain, and rocks settling over the years, the Mountain has been reconstructed and replanted twice. The latest reconstruction was designed in 1994 by landscape architect Dennis Bracale. In the above photograph, Bracale (second from right) leads the crew bringing in new rocks for the reconstruction—rocks that were rolled in on a ladder from the Nature Center just outside the gardens. In the below photograph, Bracale (left) and crew maneuver the rocks onto the Mountain. (Both, courtesy of WGA.)

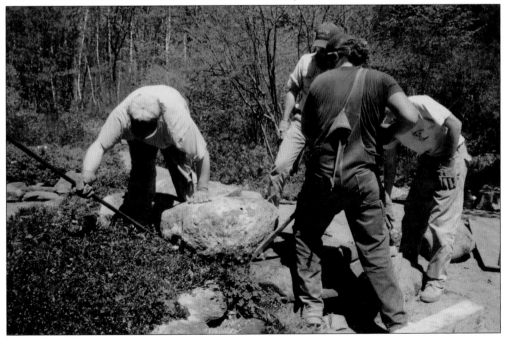

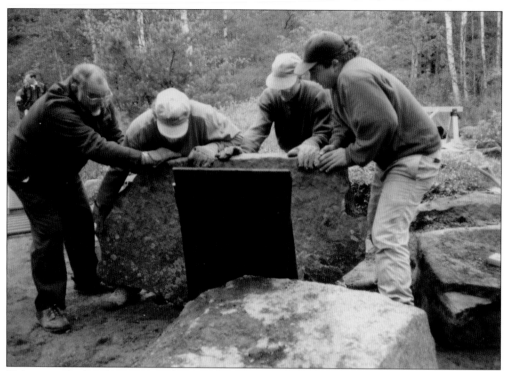

Helping with the placement and reconstruction of the Mountain is long-time WGA volunteer Don Smith (above, left), former superintendent of Dumbarton Oaks in Washington, DC. (Both, courtesy of WGA.)

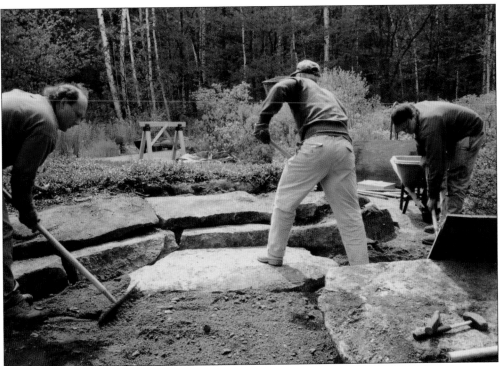

Once all the rocks were placed, soil was brought in, distributed, and packed to secure the stones and to provide a base for new plants. As is evident in the below photograph, the new plants not only blend in with the old but are thriving. (Both, courtesy of WGA.)

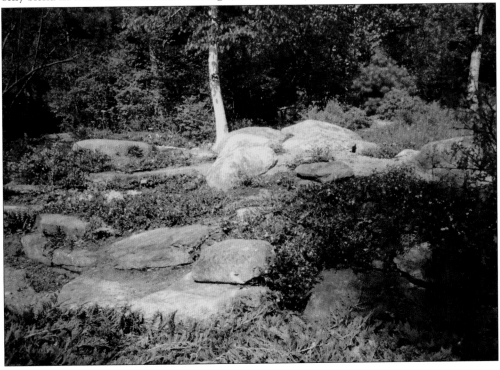

Harebell (*Campanula rotundifolia*) is found in the Wild Gardens and in many private gardens on Mount Desert Island. Although its flowers can be white, they are more commonly blue. One can find this bell-shaped flower along the shore and among rocks. (Courtesy of Josh Winer.)

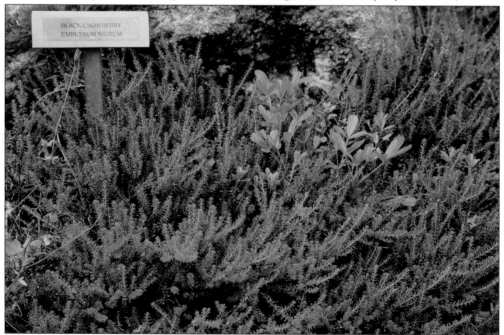

Black crowberry (*Empetrum nigrum*), which is native to cool regions of North America, Asia, and Europe, forms mats in dry rocky areas. Interspersed among the creeping stems and berries is the three-toothed cinquefoil (*Sibbaldiopsis tridentata*), another plant commonly found on mountain summits. (Courtesy of Josh Winer.)

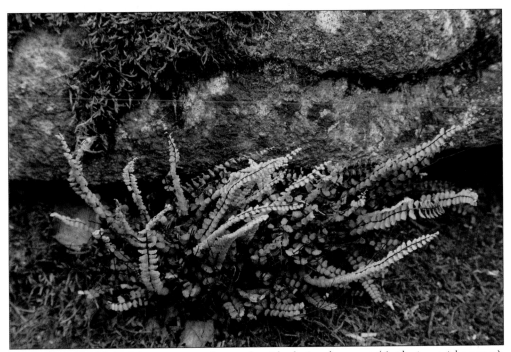

Below the rocks of the Mountain is a clump of maidenhair spleenwort (*Asplenium trichomanes*). Each of the 25 to 35 pairs of pinnae are tapered at both ends. This fern is native to most of the United States and Canada as well as Greenland. (Courtesy of Josh Winer.)

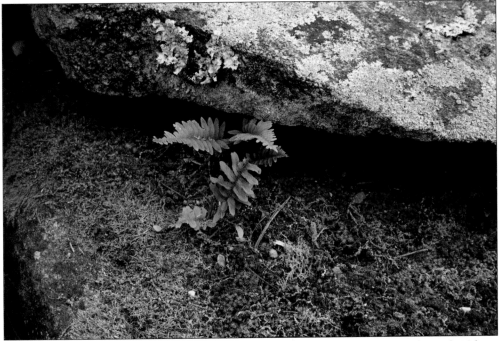

Nestled among the rocks on the Mountain is rock polypody (*Polypodium virginianum*). Hikers, rock climbers, and those walking along Acadia's 45 miles of carriage roads will encounter this fern. (Courtesy of Josh Winer.)

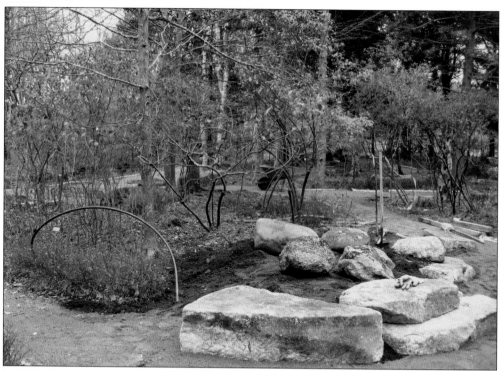

In 2012, the committee decided to redesign an area of the gardens and create the Pitch Pine Upland. A natural extension of the Mountain, this habitat contains plants one normally sees while descending from mountain summits. Construction required excavating the area and finding suitable rocks and plants, such as pitch pine (*Pinus rigida*) and sweet fern (*Comptonia peregrina*). (Both, courtesy of WGA.)

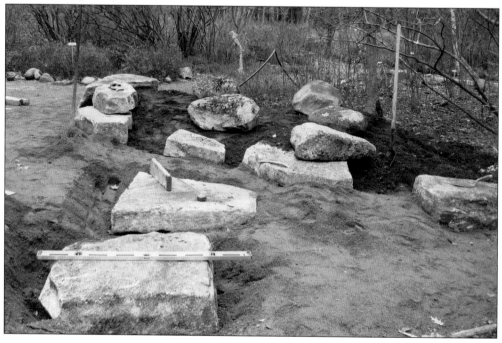

Pitch pine is the only pine in Acadia with needles in bundles of three. In the Wonderland area of Acadia National Park, pitch pine and broom crowberry (*Corema conradii*) grow together. While these two plants are found throughout the park, finding them together—thus forming a community—is unusual. (Courtesy of Kristina Beal.)

Trailing arbutus (*Epigaea repens*), sometimes called mayflower, is a harbinger of spring, since it is one of the first plants to bloom. A low-growing evergreen with white or pink flowers, it is found in Acadia in dry areas along roadsides and carriage roads. This plant is also pictured on the back cover. (Courtesy of Josh Winer.)

By the summer of 2015, the plantings in the Pitch Pine Upland were thriving despite being munched on by deer during the winter of 2012–2013. Since then, the committee has erected a seasonal fence around both the Mountain and Pitch Pine Upland. On Mount Desert Island, pitch pines can be found on south- and west-facing slopes and in old quarries. (Courtesy of Josh Winer.)

Three

MIXED AND
CONIFEROUS WOODS

Over the last 50 years, the gardens have evolved to ensure that growing conditions in the Mixed and Coniferous Woods closely approximate those in similar habitats in Acadia. While the habitats are different, the amount of shade and the composition of soil in each ensure that plants flourish in both. These conditions result from careful planning, not chance. (Courtesy of Josh Winer.)

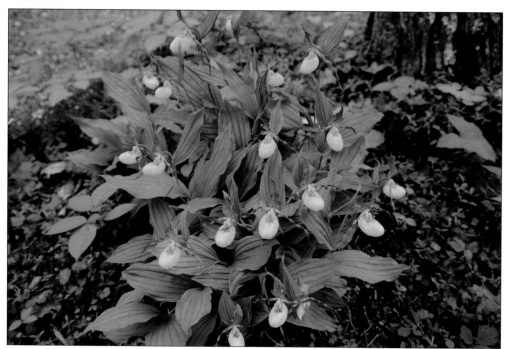

Because of the predominance of deciduous trees in the Mixed Woods and the way the leaves break down, the soil is not only less acidic but also less friable than soil in the Coniferous Woods. This fertile soil supports a number of plants, shrubs, and deciduous trees. Since deciduous trees leaf out in mid- to late May, the habitat is ideal for early spring flowers—star flower (*Lysimachia borealis*), bunchberry (*Chamaepericlymenum canadense*), nodding trillium (*Trillium cernuum*), Canada mayflower (*Maianthemum canadense*), large yellow lady's slipper (*Cypripedium pubescens*; pictured above), and red baneberry (*Actaea rubra*; pictured below); by mid-summer, the red baneberry's white flowers will have become bright, poisonous red berries. (Both, courtesy of Josh Winer.)

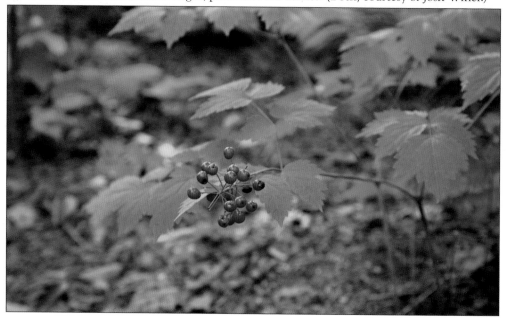

The pine needles that cover the floor of the Coniferous Woods make the soil more acidic than that in the Mixed Woods. While some shrubs like hobblebush (*Viburnum lantanoides*) grow in both habitats, the pictured hobblebush grows along a path in the Coniferous Woods. A mid-May treat is a drive along Acadia's Stanley Brook Road from Seal Harbor to the Jordan Pond House where hobblebushes line both sides of the road. (Courtesy of WGA.)

The friable soil of the Coniferous Woods supports plants spread by runners, including partridge berry (*Mitchella repens*, above left), which has dainty white flowers that turn into red berries, and goldthread (*Coptis trifolia*, above right), a perennial herb with evergreen leaves, white flowers, and golden underground runners. (Both, courtesy of WGA.)

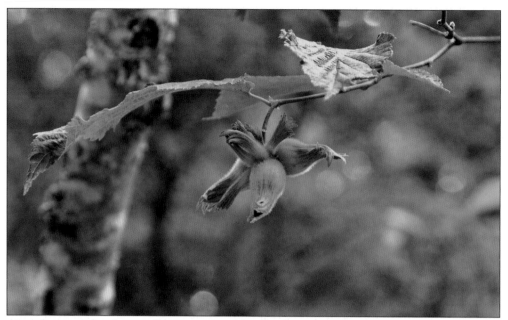

According to archival notes, "planting of trees began in earnest in 1963. . . . Under the big maples, we planted specimens of pines, spruces, hemlocks, and larch trees, obviously too many trees too close together. . . . White, yellow, and gray birches were already about [as were] white and brown ash, the overabundant red maple, beaked hazel, and two forms of arrow-wood." Beaked hazelnut (*Corylus cornuta*; pictured above) provides cover and nuts for wildlife. In the gardens, chipmunks harvest the nuts before they ripen. Maine woods also contain granite outcroppings and numerous rocks like the one shown below, which is nestled in the Coniferous Woods and covered with pine needles, mosses, and wood sorrel (*Oxalis montana*). (Both, courtesy of Josh Winer.)

One of the first trees to blossom in spring in the gardens and throughout the park is the shadbush (*Amelanchier laevis*). According to folklore, when shadbush blooms, shad begin running in streams and brooks. By mid-August, birds have harvested all the tree's purplish berries. The first shadbush in the gardens was propagated by Amory Thorndike who air layered it from a tree on his grounds. (Courtesy of Josh Winer.)

The cone of the white pine (*Pinus strobus*) is Maine's state flower. When first harvested in Maine in the 17th and 18th centuries, white pines ranged in height from 120 to 200 feet with diameters of four to six feet, making them ideal masts for sailing ships, particularly for a 120-gun ship whose mast was 40 inches wide and 120 feet high. (Courtesy of Ella Samuel.)

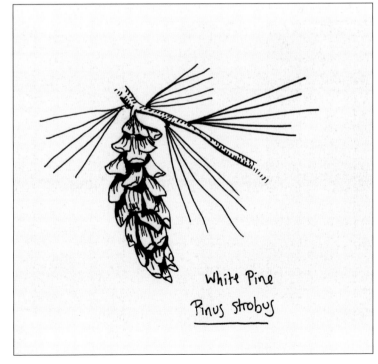

White Pine
Pinus strobus

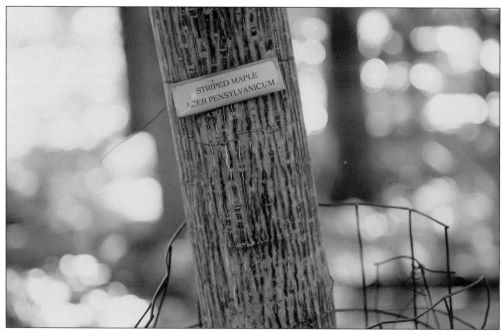

The striped maple (*Acer pensylvanicum*), commonly called moosewood, gets its name from the vertical whitish stripes on its green bark and can be found in the understory along many of Acadia's carriage roads. Another native tree in Acadia's forest, yellow birch (*Betula alleghaniensis*), is one of the largest hardwoods in northeastern North America. Not only is the bark yellow, but in fall, the leaves turn bright yellow and gold. In their two-volume study on the Wabanakis—members of the Micmac, Maliseet, Penobscot, and Passamaquoddy tribes—Prins and McBride note that the Wabanakis used the bark of both trees medicinally while the wood from yellow birch was made into a hot-water bottle. (Both, courtesy of Josh Winer.)

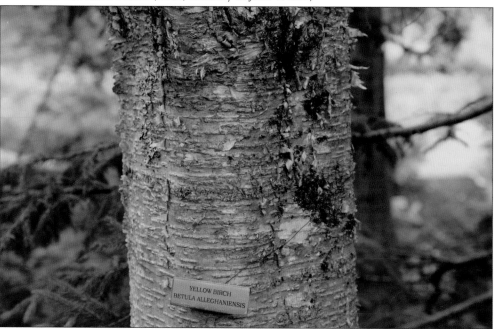

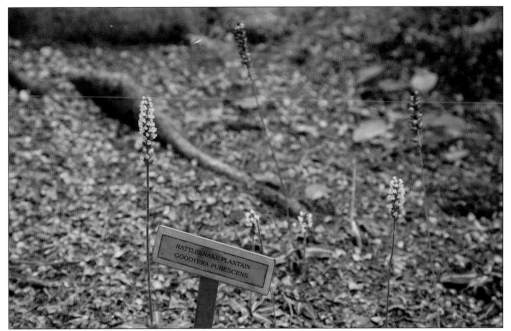

A member of the orchid family, downy rattlesnake plantain (*Goodyera pubescens*), although quite rare, is found nestled under spruce and pines in the Coniferous Woods. The brown stalks behind the white flowers are seed pods from the previous year's flowering. The oval-shaped leaves have a white stripe down the middle with smaller veins branching off in a pattern that looks similar to the skin of a snake. (Courtesy of Josh Winer.)

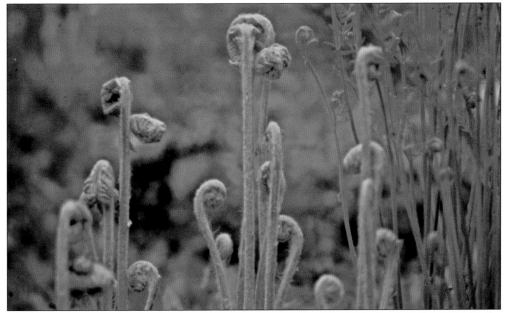

A harbinger of spring is the unfurling of the fern fronds. As shown in this photograph, the unfurling fronds, called fiddleheads, are so named because of their close resemblance to the scroll of a fiddle. Although all fiddleheads look the same to the casual observer, experts can point out distinguishing characteristics of various ferns. (Courtesy of WGA.)

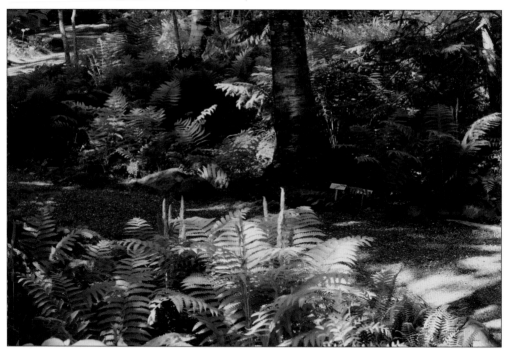

Native to the Americas and eastern Asia, cinnamon fern (*Osmundastrum cinnamomeum*), a common fern throughout Acadia National Park, gets its name from the spikes, or fertile fronds, that are cinnamon-colored at maturity. (Courtesy of Josh Winer.)

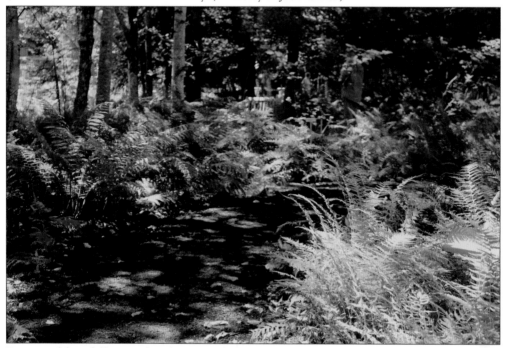

Because of their different cultural, or growing, requirements, the ferns clustered along the fern path in the Wild Gardens will not be found in similar clusters in the park but rather in environments that vary according to soil conditions, shade, and moisture. (Courtesy of WGA.)

In addition to maintaining the proper environment and ensuring plants are growing in habitats similar to those in Acadia, committee members and head gardener Geneva Langley open the gardens in spring and close them in fall. In Downeast Maine, the high winds and driving rains of nor'easters bring down branches beginning in fall and extending through much of spring. Above, Stephanie Clement, Friends of Acadia conservation director and liaison to the committee, picks up fallen branches. Below, while Langley (center) looks on, Christiaan van Heerden (left) and Helen Koch erect seasonal fencing to protect plants from browsing animals, particularly deer. (Above, courtesy of Josh Winer; below, courtesy of Floy Ervin.)

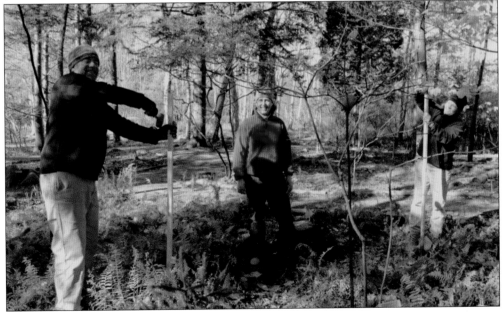

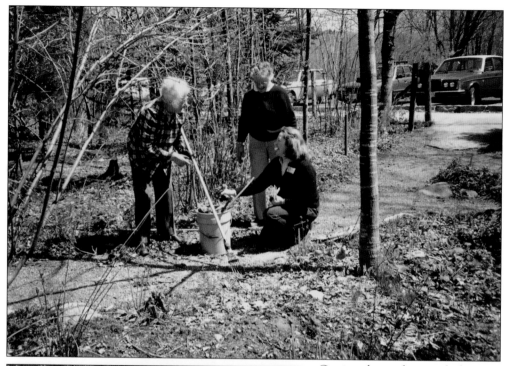

Getting the gardens ready for visitors means removing leaves and boughs that protected sensitive plants over the winter. In this mid-1980s photograph, Elizabeth Thorndike (left), Muriel Lindquist (center), and Susan Leiter remove leaves in the Mixed Woods. (Courtesy of WGA.)

Beginning in the early 1980s, when they moved to Bar Harbor permanently, Lois and West Frazier not only volunteered in the gardens—weeding in spring, greeting visitors in all seasons, and raking in fall—but regularly purchased bales of straw that were placed at the ends of paths to keep gravel from being washed into the brook during heavy rainstorms. (Courtesy of FOA.)

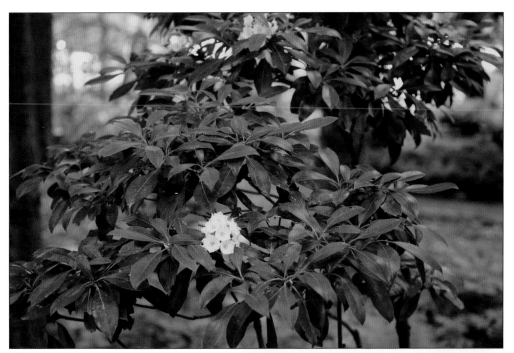

Three laurels—mountain laurel (*Kalmia latifolia*), bog laurel (*Kalmia polifolia*), and sheep laurel (*Kalmia angustifolia*)—are native to Acadia National Park although the mountain laurel has not been documented in the wild since 1980. While all three can be found in the gardens, the mountain laurel's continued flowering (above) depends on its being protected from deer in winter. An evergreen shrub, the bog laurel (right), grows in the Bog, while sheep laurel is found in the Heath, Mountain, and Mixed Woods. Sheep laurel is poisonous to livestock, hence its common name, "lambkill." (Above, courtesy of Josh Winer; right, courtesy of WGA.)

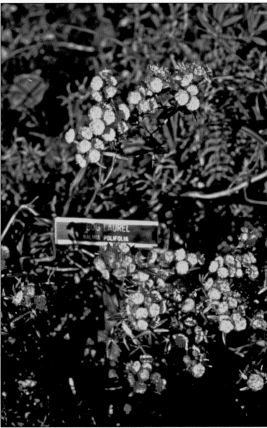

Until the mid-2000s, the gardens did not have a head gardener who coordinated the volunteers and garden upkeep. Instead, each habitat was assigned to a specific volunteer. For many years, Beverly Coleman, one of Janet TenBroeck's protégés, oversaw the care and development of the Mixed Woods. Here, Coleman (left) and TenBroeck confer about the habitat. (Courtesy of WGA.)

"A major and expensive improvement in 1973 was the construction of a new fence to shield the gardens from causal intruders . . . and to deter climbing boys. The wire is supported by well-grounded cedar posts and is quite unobtrusive in midsummer . . . and the flowering potato bean [or groundnut (*Apios americana*)] makes it positively attractive," according to archival notes. This fence was later replaced with plastic-coated green wire and new cedar posts. (Courtesy of WGA.)

Four

BIRD THICKET, ROADSIDE, AND MEADOW

Unlike the Meadow and Roadside habitats that represent plant communities disturbed by humans or nature, the Bird Thicket was designed and is maintained to attract birds and wildlife. The plants in this area (and many others throughout the gardens) provide wildlife with a variety of food—buds, nectar, fruits, and seeds. (Courtesy of WGA.)

In the Bird Thicket, the range and varying heights and shapes of the vegetation can be used for cover or nest sites. Shrubs like the staghorn sumac (*Rhus hirta*), on the left, are typically found at the edge of thickets. (Courtesy of Josh Winer.)

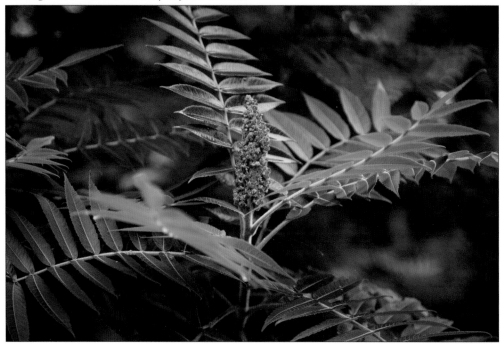

Prins and McBride point out that the Wabanakis who summered on Mount Desert Island used the fruit of the staghorn sumac (pictured) to counter loss of appetite. To make cough syrup, they added sugar to an infusion made from boiling the berries. (Courtesy of Josh Winer.)

This close-up of border plantings includes lowbush blueberry (*Vaccinium angustifolium*) in the foreground. To the left of the blueberries is Jack-in-the-pulpit (*Arisaema triphyllum*), and to the right are staghorn sumac and goldenrods. (Courtesy of Josh Winer.)

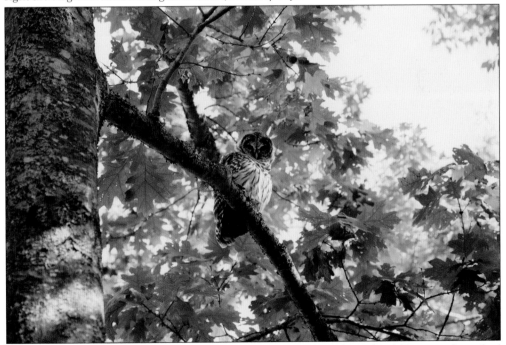

One Saturday in August 2015, visitors to the gardens spotted this barred owl (*Strix varia*) perched on a tree near the Bird Thicket. Others reported having seen or heard owls on the nearby Hemlock and Jesup Paths. (Courtesy of Josh Winer.)

Many thickets have old dying trees, such as the gardens' "woodpecker tree," that provide food and nesting areas for a variety of birds. After much searching, Douglas Coleman, a docent in the gardens, found one on his property in Marlboro, Maine. It took a team of volunteers—with help from the park—to fell the tree and carry it about 700 yards to the nearest road. (Both, courtesy of WGA.)

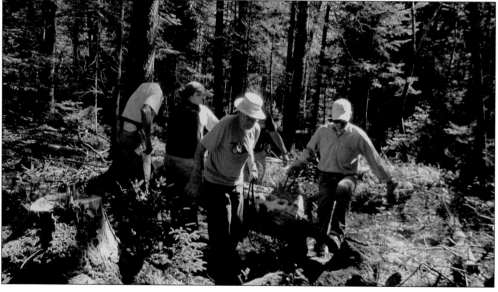

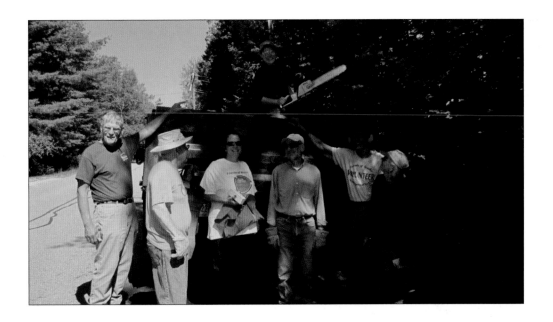

With the "woodpecker tree" safely loaded into the truck and ready to be transported from Marlboro to the gardens, the crew can relax. Much to the delight of visitors and the three species of woodpeckers found in Acadia, the tree now has a home in the Bird Thicket. (Above, courtesy of WGA; below, courtesy of Josh Winer.)

In what archival notes describe as "an exercise in imagination," committee members began to indicate specific sections "as the habitats we hoped to create in them." An area by the brook was designated Roadside, although there was no road but instead a path; along this path bordering the brook was a wealth of royal ferns (*Osmunda regalis*; pictured below). These ferns are so evenly planted that some believe they may have been planted by Acadia's founder George Dorr, although the evidence for this is anecdotal. On the other side of the path are plants typically found along New England's backcountry roads. (Above, courtesy of Josh Winer; below, courtesy of WGA.)

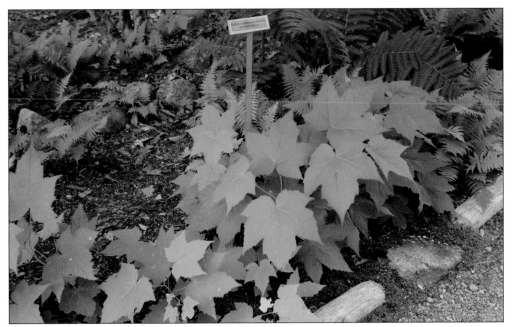

This purple-flowering raspberry (*Rubus odoratus*), now uncommon in Acadia and on Mount Desert Island, flourishes in the gardens. Unlike the nonnative wild red raspberry (*Rubus idaeus*), the fruit of the purple-flowering raspberry is inedible. The other native member of this genus, *Rubus pubescens*, or dwarf raspberry, grows closer to the ground and produces a fruit that is difficult to harvest. (Courtesy of Josh Winer.)

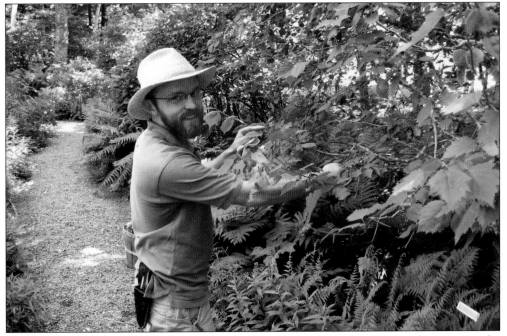

Originally an intern, Tanner Harris served as head gardener in 2007. In his five years in the gardens, Harris drew on his extensive knowledge of native plants to ensure the gardens' viability and enhance the visitor experience. (Courtesy of WGA.)

In coastal Maine, meadows are disturbed habitats frequently changed by fire, flooding, beaver activity, or human intervention, and the gardens' Meadow is no exception. To ensure that the Meadow does not return to forest, it is cut every fall and requires extensive, selective weeding. This work is especially appreciated when the Canada lily (*Lilium canadense*), goldenrods, and purple asters bloom. (Courtesy of Josh Winer.)

A staple in the Meadow is the handcrafted birch bark birdhouse. Next to it is blue vervain (*Verbena hastata*), a wildflower that grows in disturbed sites and is native to most of the 50 states and Canadian provinces. Cardinals, sparrows, and juncos eat its seeds while a variety of bees collect its nectar and sometimes the pollen. (Courtesy of Josh Winer.)

54

Although native to Acadia National Park, the Canada lily (*Lilium canadense*) has not been documented in the wild since about 1980. It thrives in the gardens, but that success depends on its being caged each night—from early spring until it flowers—to protect it from browsing deer. When it was initially planted, the committee put a cage around the corm to prevent small rodents from eating it. (Courtesy of Aimee Beal Church.)

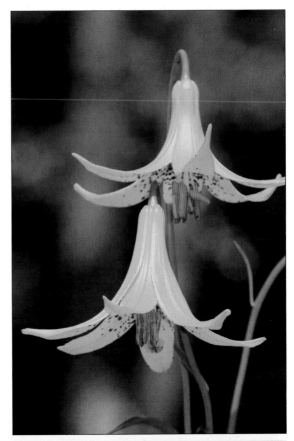

The zigzag goldenrod (*Solidago flexicaulis*) hosts a surprise visitor. (Courtesy of Josh Winer.)

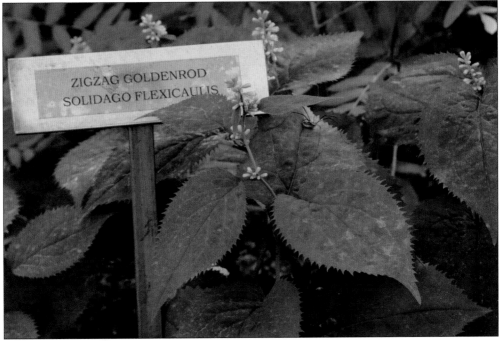

Fireweed (*Chamerion angustifolium*), which grows from sea level to subalpine zones, is found in the gardens' sunny Meadow. Its name comes from its ability to grow quickly after a fire, and it was one of the first plants that grew in London after the bombing in World War II, on Mount St. Helens after the volcano erupted in 1980, and on the island after the 1947 wildfire. (Courtesy of WGA.)

Although normally shrubby cinquefoil (*Dasiphora floribunda*) grows on rocky outcrops, it flourishes in the gardens' Meadow just across from the Mountain. One of the difficulties in maintaining a garden of plant communities is that sometimes plants simply appear in unexpected areas and thrive. (Courtesy of Josh Winer.)

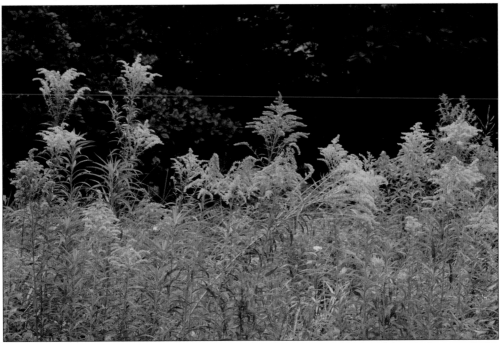

From mid-August through September, visitors can find stands of goldenrod (above) along roadsides and in meadows. Twelve native species of goldenrod are found in the gardens. The Meadow hosts five, while the other seven are found in the Mixed Woods, Mountain, Bog, Beach, and Pitch Pine Upland. Another prominent Meadow plant is the New England aster (*Symphyotrichum novae-angliae*; pictured below), which blooms from September through early October. (Both, courtesy of Josh Winer.)

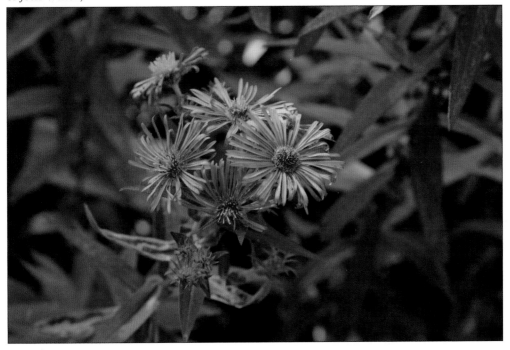

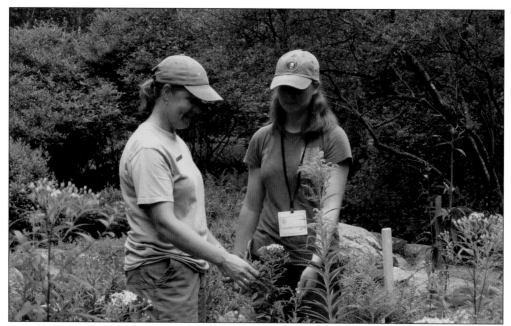

In 2009, high school student Kate Pontbriand worked as a docent and wanted significant hands-on experience. Here, head gardener Geneva Langley (left) discusses with Pontbriand one of the intricacies of weeding a wild garden: isolating a plant so it can be easily identified while leaving the impression of its occurring naturally. (Courtesy of FOA.)

Pharmacist Rebecca Brush uses a field guide to identify plants she has pressed between sheets of paper. One of Brush's contributions to the gardens was identifying plants with medicinal uses. (Courtesy of WGA.)

Five

BROOKSIDE, BEACH, AND POND

While the gardens were still in the conceptual stage, committee members recognized the brook—with its stand of royal fern (*Osmunda regalis*)—as one of the principal features of the three-quarter-acre site. The brook not only sustains ferns, willows, irises, and jack-in-the-pulpits, it also provides a place for visitors, even children, to reflect and seek solace. (Courtesy of WGA.)

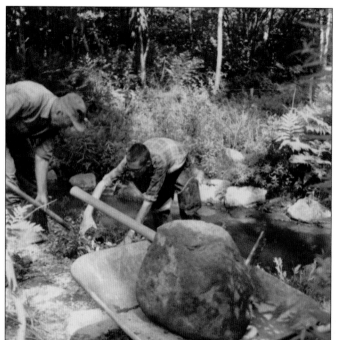

Ted Mitchell (left) assists an unidentified volunteer in preparing an area for planting. Mitchell's name occurs regularly throughout the early garden diaries of Elizabeth Thorndike and in unsigned archival notes. While committee members were out collecting plants, he prepared the sites, and upon the return of the committee members, he planted whatever they brought back. His good nature and consideration of others endeared him to both interns and committee members. (Courtesy of WGA.)

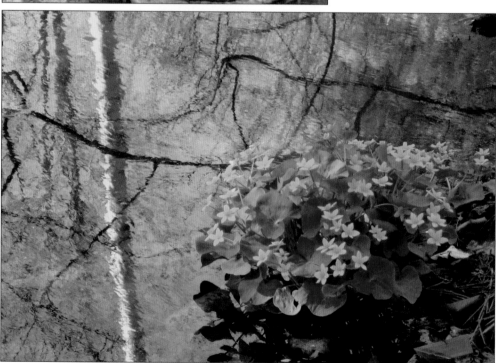

Marsh marigold (*Caltha palustris*; pictured), one of the first plants to flower in spring, is found in wet meadows and along damp edges of woodlands and thickets. In the gardens, marsh marigold and skunk cabbage (*Symplocarpus foetidus*), another early flowering plant, are very prominent in the swale by the entrance. The Wabanakis used skunk cabbage to cure headaches, asthma, and whooping cough. (Courtesy of Stephanie Clement.)

Native to eastern and midwestern North America, jack-in-the-pulpit (*Arisaema triphyllum*) is found in woods, swamps, and bogs. While no longer common in Acadia, this plant is prolific in the gardens. The green- and purple-striped bract, or spathe, curls slightly and partially covers the green flower, which is shaped like a club. The combination of the erect flower surrounded by the bract gives it the appearance of someone in a pulpit, hence its name. By late August, the flower has turned to a cluster of red berries that seed themselves. The Wabanakis used the bulb medicinally to cure tuberculosis and to treat various stomach ailments. (Right, courtesy of WGA; below, courtesy of Charlotte Stetson.)

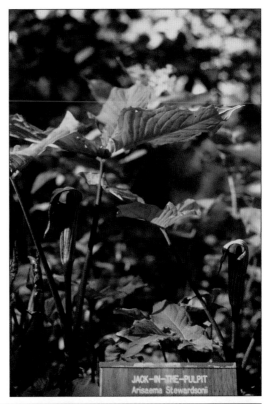

JACK-IN-THE-PULPIT
Arisaema Stewardsoni

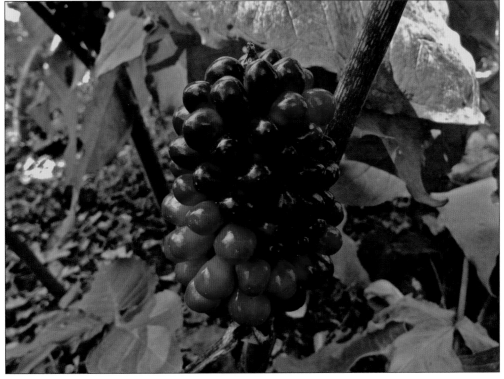

Since the brook is lined with deciduous trees, fallen leaves must often be removed. For many years, the children of committee member Anne Kozak and their friends performed this chore. After Paul Kozak went away to school, the chore was passed on to Mark Kozak, who recruited his friends Christian Horner (at left in the above image) and Dan Goldthwait (at right in the above image), grandson of committee member Ruth Goldthwait, to help with the cleanup. More recently, head gardener Geneva Langley has cleaned the brook with help from volunteers including Kozak's grandson Sam Putnam (pictured below). (Above, courtesy of WGA; below, courtesy of Josh Winer.)

With direction from committee member Don Smith and head gardener Geneva Langley, Mavis Weinberger prunes trees along the brook. Larger trees are pruned or removed by the park. (Courtesy of Carole Plenty.)

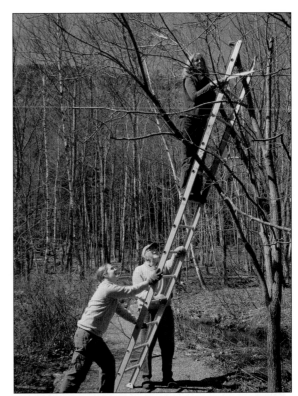

An unidentified park crew member cuts up the top of an ash tree that broke off during Hurricane Arthur in 2014. (Courtesy of Phyllis Mobraaten.)

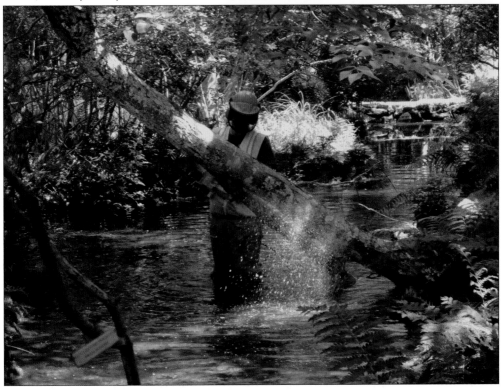

In late summer, stands of cardinal flower (*Lobelia cardinalis*) can be found beside the Wild Gardens' brook and pond. Although it was initially difficult to establish the plant, which is native to eastern North America and used medicinally by the Wabanakis, the plant now thrives. (Courtesy of Josh Winer.)

The gardens' brook merges with Cromwell Brook before flowing into the Great Meadow to the north. These waterways and nearby deciduous trees provide perfect resources for beavers to build dams and lodges. Wire screening around trees near the brook protects them from beaver activity—activity that floods roads and areas of the garden. (Courtesy of Josh Winer.)

Establishing the Beach habitat—which is a half-mile, as the crow flies, from the ocean and its salt spray so essential to some seaside plants—took considerable initiative and relentless commitment to not only finding and propagating plants but also accommodating their specific needs. To form the base, the committee used an old raincoat of Carl TenBroeck's, a tall man, and covered it with beach gravel and crushed shell. Archival notes call Barbara Joy and Margery Camp "intrepid collectors [who] soon secured, at some peril, a specimen of the rare arctic sedum (*Sedum roseum* [now called *Rhodiola rosea*]; pictured below) from a seaside cliff and planted it in our Seashore." The pair are also credited with bringing sea lavender (*Limonium carolinianum*), Scotch lovage (*Ligusticum scothicum*), silverweed (*Argentina egedii*), beach pea (*Lathyrus japonicus*), and bushels of seaweed. (Both, courtesy of WGA.)

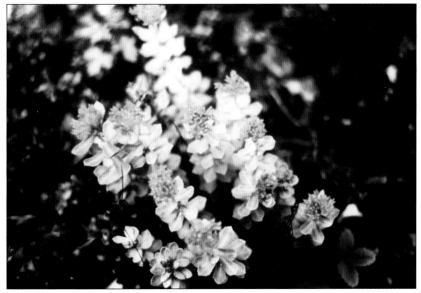

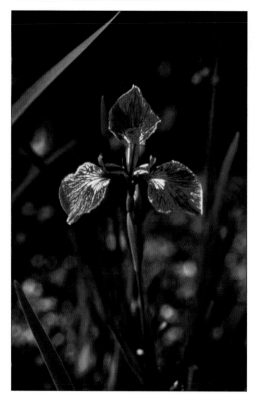

Although the Arctic iris (*Iris hookeri*; pictured at left) is uncommon on Mount Desert Island, it grows in the Beach habitat thanks to the propagating efforts of Patricia Scull, who also grew the blue flag iris (*Iris versicolor*; pictured below) from seed she collected. Another Beach plant, seaside bluebells (*Mertensia maritima*), which archival notes describe as growing "precariously at the very edge of the sea," did not survive in the gardens despite the efforts of Brenda Les, who grew the plant from seed and "sometimes succeeded in making it thrive." (Both, courtesy of WGA.)

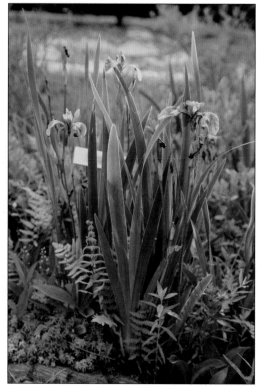

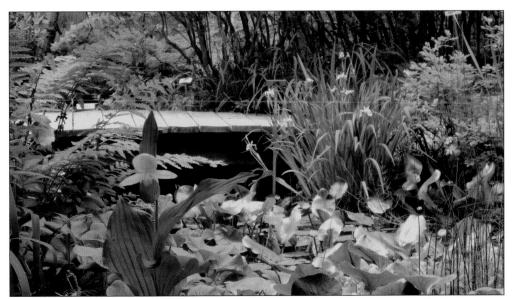

At the far end of the brook by the Marsh is the Pond habitat—a habitat that, in the above photograph, looks natural and tranquil but whose iterations over the years were hardly tranquil and took considerable toil and perseverance. The showy lady's slipper (*Cypripedium reginae*; pictured below) is the second at that site. When the original plant did not come back in the late 1990s, the committee purchased a new plant with funds from the Garden Club of America's Founders Fund Award. The Garden Club of Mount Desert not only nominated the Wild Gardens for the national award but assisted in writing that proposal. In 1965, Dr. A.E. Brower, Maine state entomologist, brought "us our first specimen, a sturdy plant with bare white fleshy roots spreading two feet on each side," as recorded in archival notes. (Both, courtesy of WGA.)

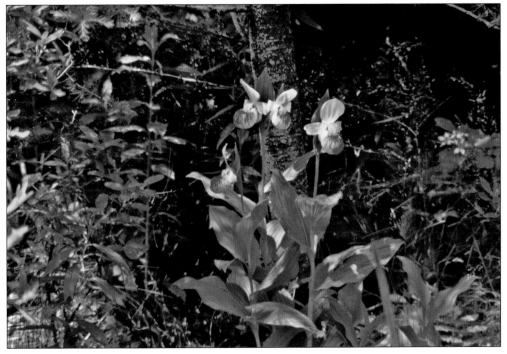

The site of the current Pond habitat was originally the Bog and later a marsh. In 1978, two interns—Andrea Lepicio and Bill Bergevin (both pictured at left)—dug the site by hand. Since water leaked from the wooden dam that had been constructed to contain the first pond, the committee used a backhoe to dig a second pond at the same site. (Both, courtesy of WGA.)

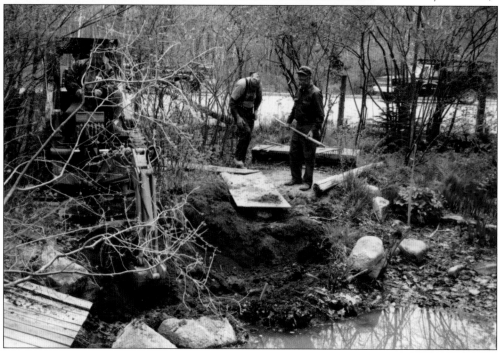

In shallow water, pickerelweed (*Pontederia cordata*) can grow to three to four feet. Although native to Acadia, the range of the genus *Pontederia* extends from Canada to Argentina. The Wabanakis as well as other First Nations people used pickerelweed to prevent pregnancies. In Acadia, visitors can find pickerelweed to the left of the Eagle Lake boat landing. (Courtesy of WGA.)

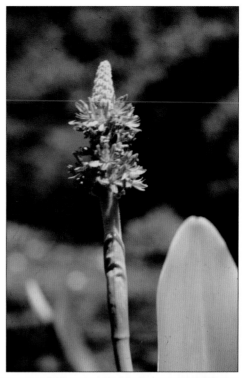

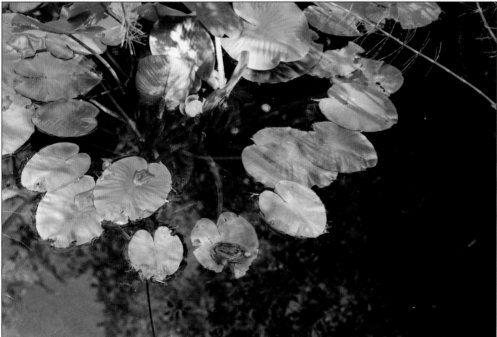

Ubiquitous in the ponds of Acadia and Mount Desert Island, yellow pond lilies (*Nuphar variegata*) delight young visitors to the gardens, particularly if a frog is sunning itself on one of the leaves. At events like Junior Ranger Day in early May, visitors of all ages can see the eggs of the wood frog and salamanders. (Courtesy of Josh Winer.)

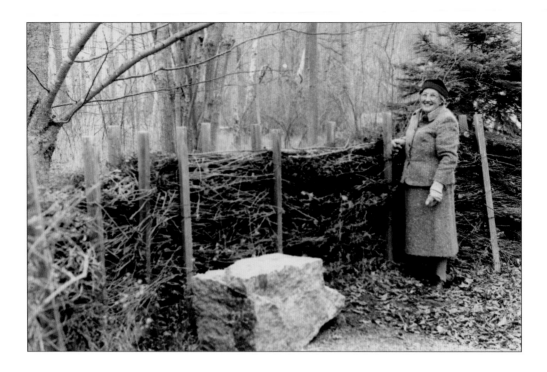

In the Wild Gardens' work area are compost bins, mounds of soil, gravel for paths, a nursery for nurturing future plantings, and piles of "aesthetic things" like rustic logs and moss-covered rocks. To separate the work area from the rest of the gardens, Dora "Dodie" Pierce came up with the idea of building a wattle, a rustic fence she had seen in England. She and her husband, Eliot, erected the first one, and others have continued the tradition. In the below photograph, Larry Mobraaten (left), Edward Leiter (center), and Douglas Coleman renew the spirea twigs that comprise the current wattle. (Both, courtesy of WGA.)

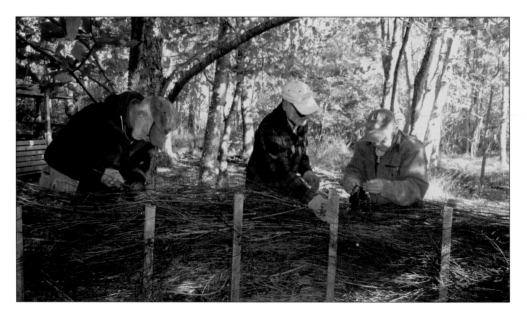

Six

BOG, MARSH, AND HEATH

In 1962, as the committee was deciding the location of habitats, it put the Bog in a swale. Problems with drainage and acidity, however, made it difficult to maintain conditions for plants to thrive. In 1970, park crews excavated a wet area beyond the brook and added 20 cubic yards of peat from a bog in Penobscot owned by committee member Elizabeth Owens. (Courtesy of WGA.)

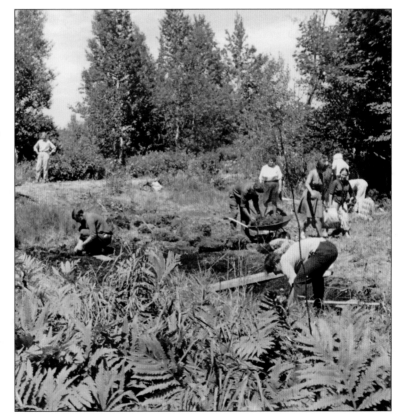

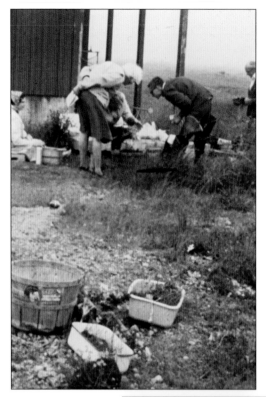

When the park first gave the land to the Wild Gardens committee, it stipulated that plants must be indigenous to Acadia and that plants could not be collected in the park. While National Park Service policy stipulates that visitors, for example, cannot cut flowers or remove cobbles from beaches, it does allow visitors to pick berries. In late July when the wild blueberries ripen, residents and visitors to Acadia pick berries on mountain summits and along carriage roads. In the Wild Gardens, however, visitors cannot pick the berries. Since plants could not be collected in the park, committee members propagated plants or collected them on private lands with the landowner's permission. While these trips involved considerable work and travel, they generally included a picnic—and sometimes a swim. (Both, courtesy of WGA.)

In addition to getting peat from Elizabeth Owens's bog, members collected plants. At right, Elizabeth Gorer (left) and Ruth Goldthwait bring plants back to Owens's station wagon—a wagon the intrepid Owens drove to numerous sites, many of which were on old logging roads. But as long as she could see Acadia's mountains in the distance, she was certain she knew where she was even when on the other side of Frenchman Bay. (Both, courtesy of WGA.)

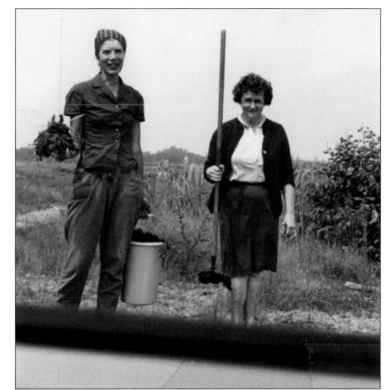

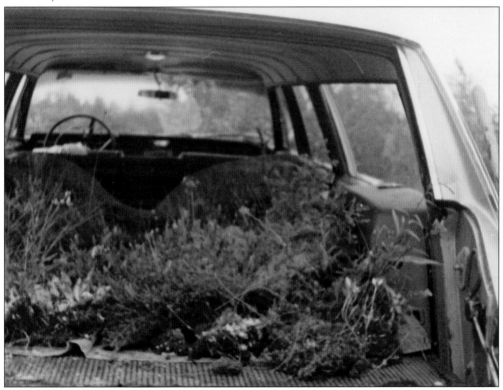

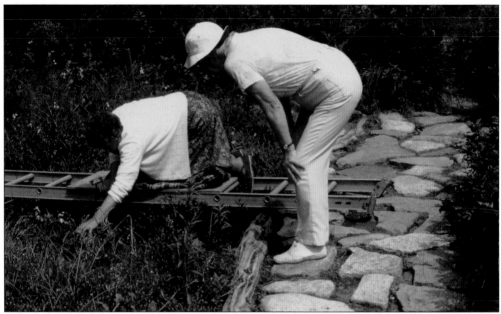

While procuring plants was challenging, more challenging was weeding the Bog without harming delicate plants. Elizabeth Owens and Ruth Goldthwait were ingenious: They laid a ladder across the Bog, as shown above, and Goldthwait weeded from its rungs as Katrina Hummel watched. Goldthwait (at left in the below image) and Owens also weeded perimeter plants while kneeling on cobbles. As original members of the committee, these two women oversaw the Bog's development and expansion for almost 25 years before passing oversight to younger members. Since the Bog was excavated in a wet area, the park built a raised stone walkway around its perimeter; the walkway has been reset several times. Plans are currently being drawn for a reconstruction to address the walkway and flooding after major storms. (Both, courtesy of WGA.)

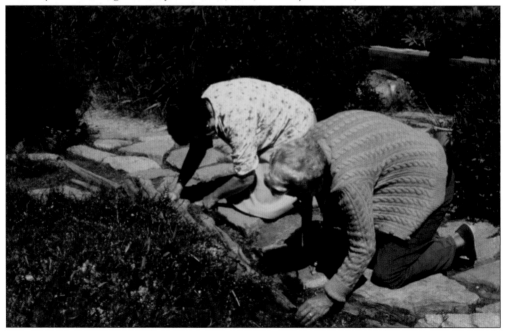

Round-leaved sundew (*Drosera rotundifolia*) is circumboreal and carnivorous. Since the peat that forms the substrate of bogs is sterile, plants must seek other ways of obtaining nutrients. A sticky substance on the leaves of sundew attracts and traps insects. (Courtesy of WGA.)

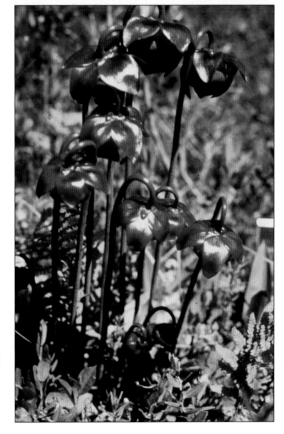

The pitcher plant (*Sarracenia purpurea*), another carnivorous plant, attracts insects into its pitcher-like flower where they drown. Once decomposed, the insects produce nutrients that are absorbed by the plant. (Courtesy of WGA.)

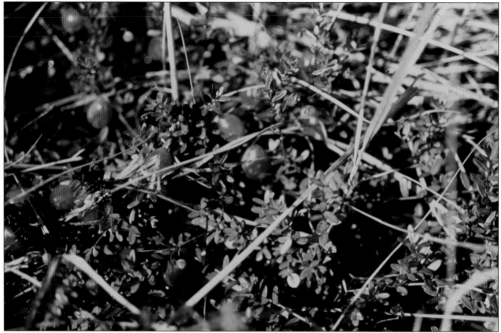

Bog cranberry (*Vaccinium macrocarpon*)—one of three cranberries native to Acadia National Park (all three are edible)—is easily harvested and is the cranberry that typically accompanies a Thanksgiving turkey. (Courtesy of WGA.)

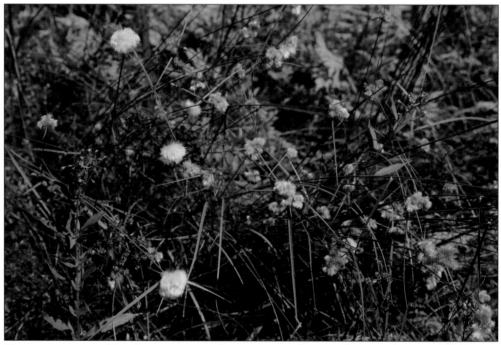

Tawny cotton-grass (*Eriophorum virginicum*) can grow as solitary stalks or in clusters. Native to the New England states and eastern Canada, this plant has white or copper-colored tufts resembling cotton balls. (Courtesy of Josh Winer.)

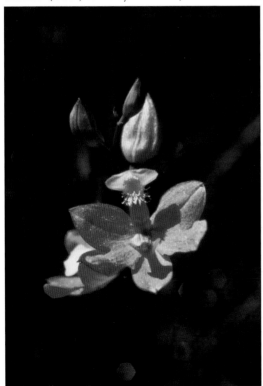

In the past, the Bog was home to four native orchids: rose pogonia (*Pogonia ophioglossoides*; pictured at right and on the back cover), grass pink (*Calopogon tuberosus*; pictured below), dragon's mouth (*Arethusa bulbosa*), and green woodland orchis (*Platanthera clavellata*). In 2015, only the rose pogonia bloomed, and it is flourishing. The reconstruction of the Bog should aid in reestablishing favorable growing conditions for orchids. (Both, courtesy of WGA.)

Like the Pond and the Bog habitats, the Marsh has been moved and reconstructed. In 1970, when the Bog was relocated to its current location, the former bog was turned into a freshwater marsh. Landscape architect Patrick Chassé later designed a new pond with an adjacent marsh—the one pictured here. (Courtesy of WGA.)

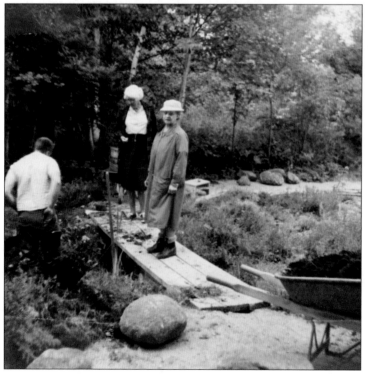

Amy Garland (foreground)—always referred to as "Mrs. Lewis Garland" in archival notes—discusses Marsh plantings with Janet TenBroeck. Garland drew on knowledge gleaned from working with landscape gardener Beatrix Farrand at Farrand's Reef Point Gardens in Bar Harbor and later at Garland Farm in Salisbury Cove, where Farrand designed her last garden. (Courtesy of WGA.)

Clumps of dark-green bulrush (*Scirpus atrovirens*) line the path between the Pond and work area. This bulrush has light chocolate-bronze seed clusters that can be viable for up to 40 years. (Courtesy of Josh Winer.)

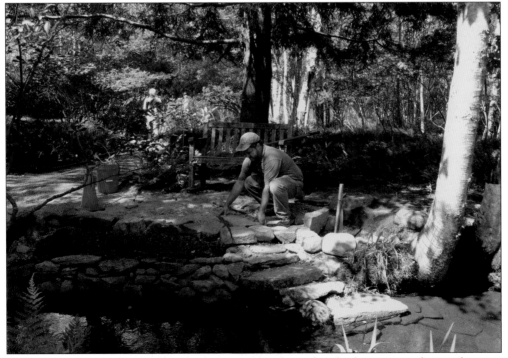

Noah Sawyer, from College of the Atlantic, interned in the gardens for three years and now volunteers. In 2014, he reset stones leading to the brook and adjacent Marsh. (Courtesy of WGA.)

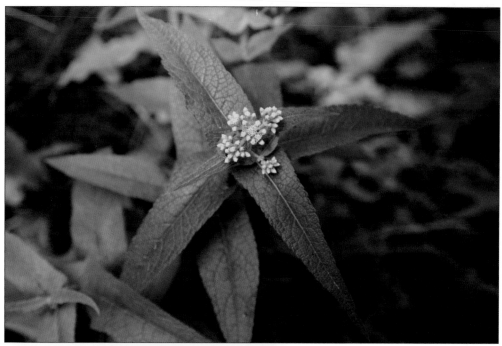

Boneset (*Eupatorium perfoliatum*) had a wide range of medicinal uses among the Wabanakis. Prins and McBride note the Wabanakis made an infusion to remedy kidney problems, to stop hemorrhaging, and to cure colds, sore throats, gonorrhea, and smallpox. (Courtesy of Josh Winer.)

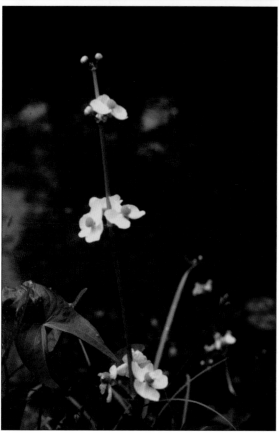

Arrowhead (*Sagittaria latifolia*), found in wet areas throughout Acadia, can easily be found at the Eagle Lake boat landing. Although one of its common names is duck potato, ducks do not eat this plant, but beavers do. (Courtesy of WGA.)

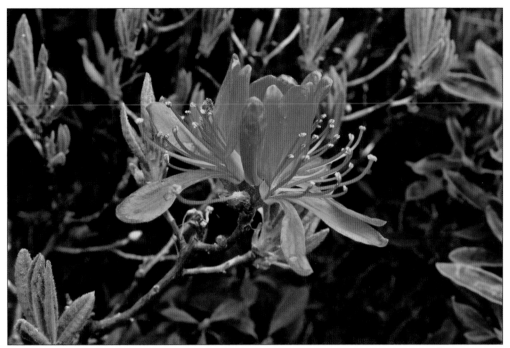

Characterized by highly acidic, well-drained soils, heaths contain ericaceous plants—plants ranging from ground covers to shrubs. By mid-May, the Great Meadow north of the gardens and many areas along the trails and carriage roads are ablaze with rhodora (*Rhododendron canadense*; pictured above). While the blossoms can be either purple or white, the purple variety is most common. According to archival notes, "Barbara Joy and Marjorie Camp found on their own property the rare white rhodora and planted it among the typical purplish ones in the Heath." The fruits of both the highbush blueberry (*Vaccinium corymbosum*) and the more common lowbush blueberry (*Vaccinium angustifolium*; pictured below) are edible. In fall, the leaves of both species turn red. (Above, courtesy of Charlotte Stetson; below, courtesy of Josh Winer.)

While mountain holly (*Ilex mucronata*; pictured) is not found as frequently in Acadia as winterberry (*Ilex verticillata*), its bright red berries provide much-needed food for songbirds migrating south in fall. (Courtesy of Josh Winer.)

When glaciers retreated, they left behind plants like bear oak, at the northern limit of its range, and Labrador tea (*Rhododendron groenlandicum*; pictured), at the southern end of its range. In the gardens, this evergreen shrub is found in the Bog, Marsh, and Heath. (Courtesy of WGA.)

Seven

OUTREACH

In 2011, several students in Dru Colbert's graphic design class at College of the Atlantic (COA) in Bar Harbor designed posters to publicize docent training and other volunteer opportunities in the gardens. This wood lily (*Lilium philadelphicum*) poster created by Devin Altabelto encouraged volunteers and raised awareness. While designing the poster, Altabelto worked with committee member Anne Kozak and Friends of Acadia communications coordinator Aimee Beal Church. (Courtesy of Devin Altabelto.)

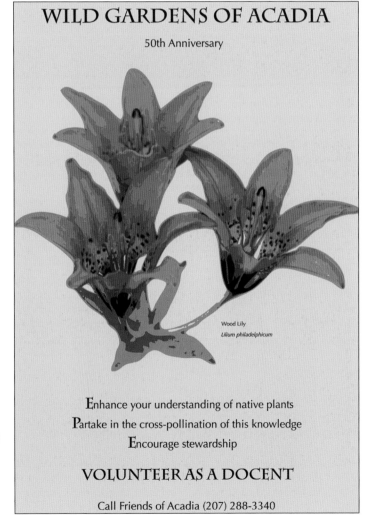

WILD GARDENS OF ACADIA

50th Anniversary

Wood Lily
Lilium philadelphicum

Enhance your understanding of native plants

Partake in the cross-pollination of this knowledge

Encourage stewardship

VOLUNTEER AS A DOCENT

Call Friends of Acadia (207) 288-3340

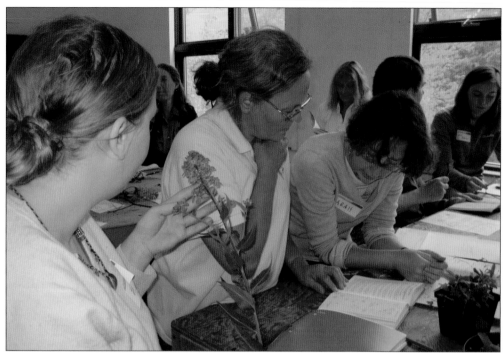

In June 2009, approximately 40 people signed up for a day-long workshop on docent training at College of the Atlantic. In the morning session, Anne Kozak spoke about the history of the gardens and the women who designed, developed, and maintained them. This was followed by two sessions—one on plant taxonomy and plant communities and one in the gardens with Susan Leiter. Above, Helen Koch (center) uses a field guide to show a participant how to key out a plant. Below, head gardener Geneva Langley (foreground) talks about plant communities. To provide context for earlier discussions, participants toured the gardens with Leiter. (Both, courtesy of FOA.)

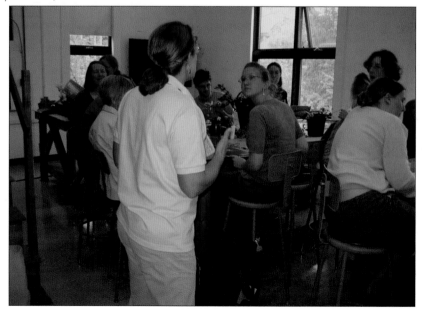

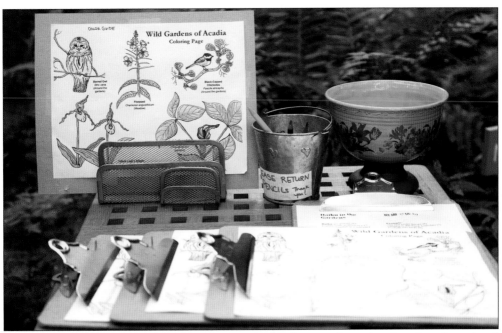

To engage children and their families, interns and volunteers have developed garden-related projects, including a scavenger hunt, coloring pages, and writing haikus. These activities build on those featured during Junior Ranger Day and class visits. When it is not raining, these are set out on the table each morning. To enhance understanding of science, intern Ella Samuel, from College of the Atlantic, made a coloring book. She not only drew a number of plants and the barred owl but colored them so that children could have a better sense of what the plants and animals actually look like. Below, Griffin Winer sits by the Pond as he works on the scavenger hunt and draws a picture of "a place for frogs to rest." (Both, courtesy of Josh Winer.)

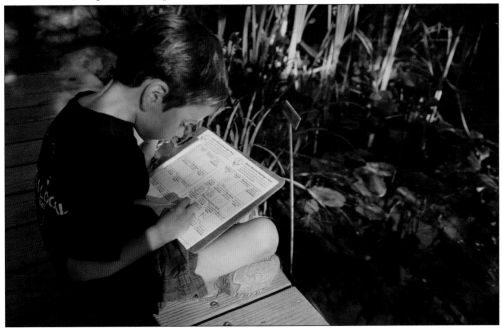

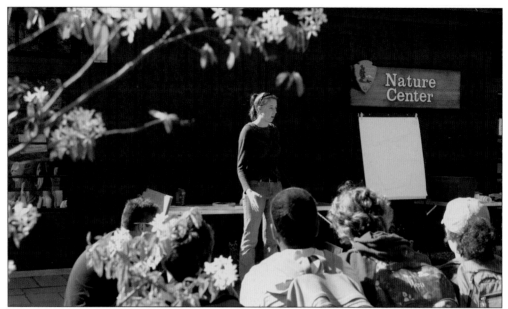

In 2008, College of the Atlantic intern Sarah Short Heller, working with head gardener Tom Lawrence, combined science and art to help schoolchildren map plant communities. Students from Mount Desert Elementary School in Northeast Harbor observed plants in specific habitats and then drew them. At the end of the session, students described the role of the plant they drew. (Courtesy of Tom Lawrence.)

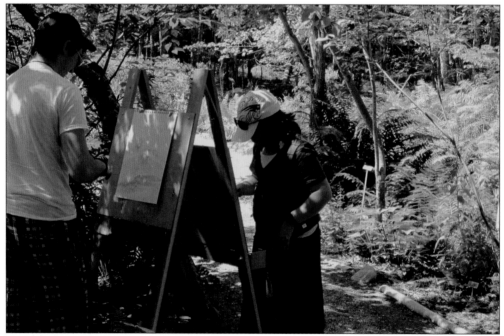

Each Wednesday, provided the weather is good, Phyllis Mobraaten sets up easels by the brook and invites visitors to draw what they see. This allows participants to not only be creative but also to see nature through a different lens—a lens that fosters their understanding and appreciation of the natural world. (Courtesy of Phyllis Mobraaten.)

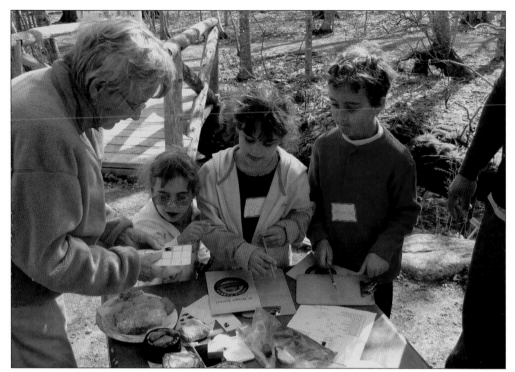

In spring, interpretative rangers in Acadia organize Junior Ranger Day to provide children with an opportunity to meet requirements for becoming a junior ranger; these requirements involve participating in ranger-led programs and completing activities in a workbook such as the one shown on the table. Former Wild Gardens chair Barbara Cole certifies that these future junior rangers have successfully completed an activity in the gardens. (Courtesy of WGA.)

To enhance the visitor experience, the committee posts information about what is in bloom, what birds have been sighted, and other relevant garden information. In 2014, the park placed a permanent interpretative wayside sign at the entrance near the Nature Center to orient visitors. (Courtesy of Josh Winer.)

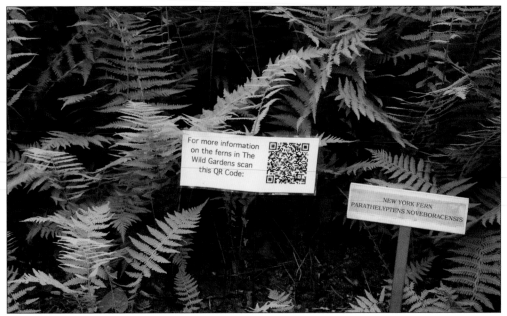

For more information on the ferns in The Wild Gardens scan this QR Code:

NEW YORK FERN
PARATHELYPTIENS NOVEBORACENSIS

Since 2013, the Acadia Youth Technology Team—a team comprised of high school and college students—has worked with the park and FOA volunteers to explore how technology can improve the visitor experience. They have placed QR codes near the fern path and entrances so visitors can use their phones to access information about ferns. The project is ongoing and, if successful, may be expanded. (Courtesy of Josh Winer.)

Look UP Maine!

This ASH TREE gives back

$ 209

worth of environmental benefits EVERY YEAR.

The emerald ash borer, an invasive pest that could wipe out all ash trees, threatens Maine's forests. Since these beetles can be transported into the park on firewood from out of state, the park marked ash trees with purple ribbon and information about its economic impact. Ash is used to make many wood products, including baseball bats, and Native Americans use black ash to make baskets. (Courtesy of Josh Winer.)

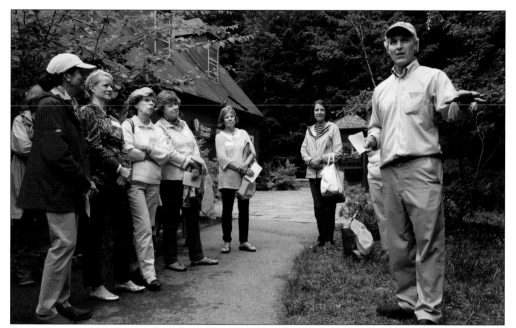

In addition to maintaining the gardens, committee members—in partnership with the park and FOA—raise money for salaries, supplies, improvements, and educational initiatives. Raising money takes many forms: direct solicitation, plant sales, tours, and sales of brochures and postcards. In 2014, Julie Leisenring, Ann Kinney, and Elizabeth Hodder (daughter of founding member Elizabeth Owens) hosted a tour of the gardens and tea for members of the Garden Club of Mount Desert. In greeting guests at the gardens, FOA president David MacDonald (at right in the above image) talked about the importance of the gardens for the park in helping visitors learn more about native plants and the role they play in maintaining ecosystems. Below, Hodder greets people at her home, Open Water. (Both, courtesy of FOA.)

Geneva Thorndike (left), a great-niece by marriage of founding member Elizabeth Thorndike, talks with Mary Reath about the gardens. Thorndike and Anne Kozak are chairing a campaign through FOA to endow the head gardener's position and educational initiatives. (Courtesy of FOA.)

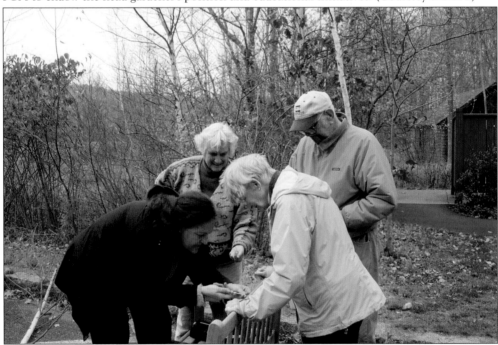

FOA's development director, Lisa Horsch Clark (left), along with Anne Kozak (behind Horsch Clark), Don Smith (in green jacket), and Barbara Cole (in blue jacket) discuss the best way to attach a bronze label indicating that this bench honors Patricia Scull; the bench was donated by Scull's son Eliot and his wife, Tina. Many of the benches in the gardens have been donated in honor or memory of committee members and friends. (Courtesy of Helen Koch.)

For many years, Wild Gardens docent Douglas Coleman worked at The Jackson Laboratory in Bar Harbor. His research showing that a genetic component was involved in obesity received numerous international prizes—prizes he shared with Jeffrey Friedman of Rockefeller University. After travelling to Saudi Arabia in 2013 to receive the King Faisal International Prize in Medicine, Coleman donated a portion of that prize money to the Wild Gardens' endowment fund in memory of his late wife, Beverly, who also volunteered in the gardens. Before presenting the check to David MacDonald and Acadia superintendent Sheridan Steele, Coleman, who intended the gift to spur other donations, invited those attending the luncheon to walk on his Marlboro, Maine, property. In the image at right, Coleman (center) walks with MacDonald (left) and Steele. Below are Coleman (left), MacDonald (center), and Steele. (Both, courtesy of FOA.)

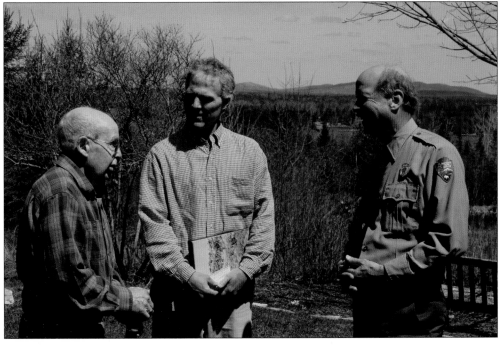

In 2011, at the 50th anniversary of the gardens, Marla O'Byrne, then president of FOA, thanked the volunteers who developed and sustain the gardens. In 2010, O'Byrne, park superintendent Sheridan Steele, and Lili Pew (then FOA board chair) played pivotal roles in initiating a memorandum of understanding between the park and FOA, making the Wild Gardens a project of FOA and thus ensuring the gardens' long-term viability. (Courtesy of FOA.)

A Quick Guide to

Common Ferns

of the Wild Gardens of Acadia

In 2007, the Hancock County Master Gardeners Volunteers program approved the Wild Gardens as a volunteer site. Master gardeners watered, weeded, and opened and closed the gardens. With volunteers, they developed a fern brochure to help visitors learn more about ferns they see along the fern path and throughout the park. (Courtesy of FOA.)

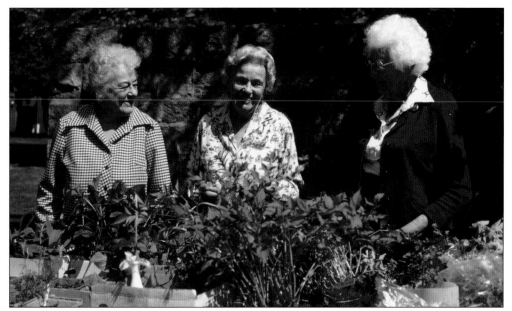

In the early days of the gardens, Elizabeth Thorndike (left), Elizabeth Owens (center), and Janet TenBroeck—along with other committee members—organized plant sales in the spring and fall to raise money to support the gardens. These were held on the village green in Bar Harbor in front of the monument honoring those who served in the armed forces. (Courtesy of WGA.)

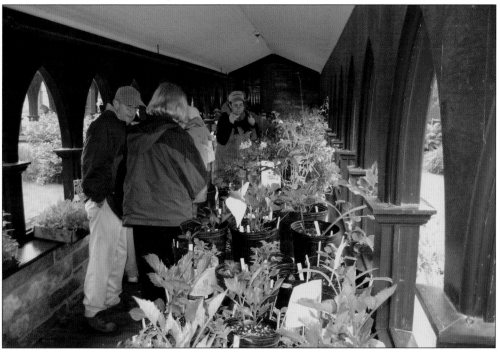

As the number of plants and those purchasing plants increased, the sale moved down Mount Desert Street to the parking lot and cloisters of St. Saviour's Church. Plants are solicited from private estates, gardens of members and friends, and nurseries on and off Mount Desert Island. (Courtesy of FOA.)

The Wild Gardens of Acadia

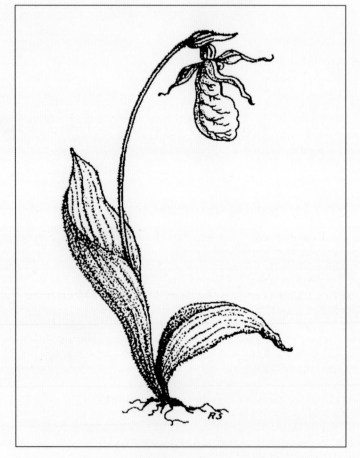

Displaying, preserving, and propagating Acadia's native flora

Sieur de Monts Spring
Acadia National Park

Since the first printing of the Wild Gardens brochure in 1970, it has played a major role in educating visitors about the different habitats and plant communities. Ruth Soper's pen-and-ink sketch of a pink lady's slipper has become the logo of the Wild Gardens. (Courtesy of WGA.)

BIBLIOGRAPHY

Archival notes. Acadia National Park Archives.

Donovan, David. "Our Wild Gardens: A Unique and Wild Teacher." *FOA Journal* 17, no. 2 (Summer 2012), 10–11.

Dorr, George B. "Sieur de Monts National Monument and Wild Gardens of Acadia." Sieur de Monts Publication XXII. Bar Harbor, National Park Service. 1919.

Haines, Arthur. *New England Wild Flower Society's Flora Novae Angliae: A Manual for the Identification of Native and Naturalized Higher Vascular Plants of New England.* New Haven, CT: Yale University Press, 2011.

Kozak, Anne. Remarks at the 50th Anniversary Celebration of the Wild Gardens of Acadia. Acadia National Park Archives, 2011.

———. "The White Pine and Politics: Then and Now." *Bar Harbor Times*, July 16, 1987: C1, C3.

———. "Wild Gardens of Acadia: Two Women Who Helped Sow the Seeds Reap the Fruits." *Bar Harbor Times*, October 19, 1989: B1–3.

Mittelhauser, Glenn H., Linda L. Gregory, Sally C. Rooney, and Jill Weber. *The Plants of Acadia National Park.* Orono: University of Maine Press, 2010.

National Park Service. *Cultural Landscape Inventory 2009: Sieur de Monts Spring.* Boston: Olmsted Center for Landscape Preservation, National Park Service, 2009.

———. *Pathmakers: Cultural Landscape Report for the Historic Hiking Trail System of Mount Desert Island.* Boston: Olmsted Center for Landscape Preservation, National Park Service, 2006.

New England Wild Flower Society. Framingham, MA. (gobotany.newenglandwild.org)

Prins, Harald E.L. and Bunny McBride. *Asticou's Island Domain: Wabanaki Peoples at Mount Desert Island 1500–2000,* vol. 2. Boston: National Park Service, 2007.

TenBroeck, Janet. "As I see it." Acadia National Park Archives.

———. Notes. Acadia National Park Archives.

Thorndike, Elizabeth F. Garden Diaries 1963–1980. Acadia National Park Archives.

———. Memo to Superintendent Harold Hubler and WGA Committee Members. Acadia National Park Archives, October 20, 1964.

———. Remarks at the 25th Anniversary Celebration of the Wild Gardens of Acadia. Acadia National Park Archives, 1986.

Wherry, Edgar T. *The Wild Flowers of Mount Desert Island, Maine.* Northeast Harbor, ME: The Garden Club of Mount Desert, 1928.

DISCOVER THOUSANDS OF LOCAL HISTORY BOOKS
FEATURING MILLIONS OF VINTAGE IMAGES

Arcadia Publishing, the leading local history publisher in the United States, is committed to making history accessible and meaningful through publishing books that celebrate and preserve the heritage of America's people and places.

Find more books like this at
www.arcadiapublishing.com

Search for your hometown history, your old stomping grounds, and even your favorite sports team.

Consistent with our mission to preserve history on a local level, this book was printed in South Carolina on American-made paper and manufactured entirely in the United States. Products carrying the accredited Forest Stewardship Council (FSC) label are printed on 100 percent FSC-certified paper.

MADE IN THE USA